Big Art
SMALL CANVAS

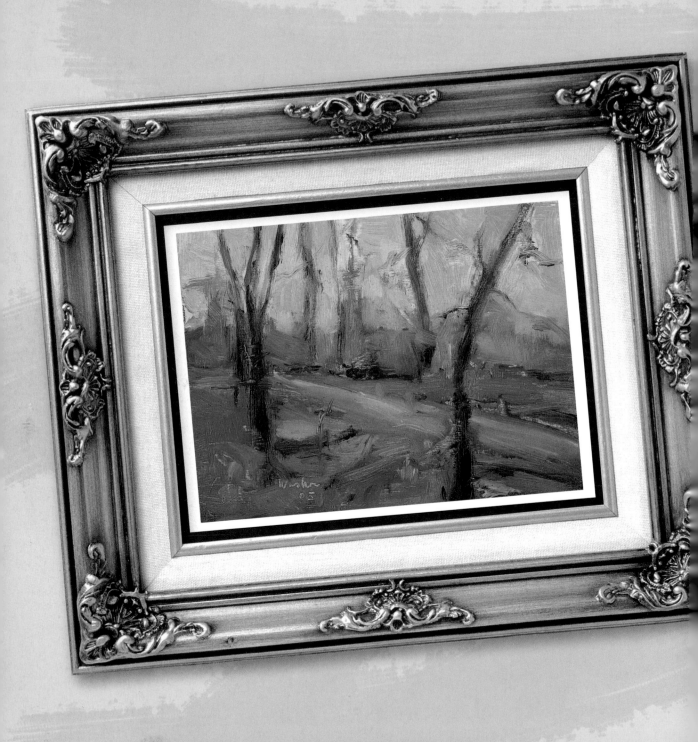

Big Art
small canvas
paint easier, faster & better with small oils

∽ Joyce Washor

NORTH LIGHT BOOKS
CINCINNATI, OHIO
www.artistsnetwork.com

ART FROM PAGE 2:

LANDSCAPE #0538 ~ Oil on board, 3" × 4" (8cm × 10cm)

fw
F+W PUBLICATIONS, INC.

Other fine North Light Books are available from your local bookstore, art supply store or direct from the publisher.

10 09 08 07 06 5 4 3 2 1

DISTRIBUTED IN CANADA BY FRASER DIRECT
100 Armstrong Avenue
Georgetown, ON, Canada L7G 5S4
Tel: (905) 877-4411

DISTRIBUTED IN THE U.K. AND EUROPE BY DAVID & CHARLES
Brunel House, Newton Abbot, Devon, TQ12 4PU, England
Tel: (+44) 1626 323200, Fax: (+44) 1626 323319
Email: mail@davidandcharles.co.uk

DISTRIBUTED IN AUSTRALIA BY CAPRICORN LINK
P.O. Box 704, S. Windsor NSW, 2756 Australia
Tel: (02) 4577-3555

Library of Congress Cataloging in Publication Data
Washor, Joyce
 Big art, small canvas : paint easier, better and faster with small oils / Joyce Washor.
 p. cm.
 Includes index.
 ISBN-13: 978-1-58180-777-6 (alk. paper)
 ISBN-10: 1-58180-777-5 (alk. paper)
 1. Painting—Technique. 2. Small painting. I. Title: Paint easier, better and faster with small oils. II. Title.
 ND1473.W37 2006
 751.45—dc22 2006004409

Edited by Erin Nevius
Designed by Wendy Dunning
Production art by Kathy Bergstrom
Production coordinated by Matt Wagner

About the Author

*J*oyce Washor lives and works in Riverdale, New York. She is a graduate of Douglass College, Rutgers University and The Woodstock School of Art. Washor teaches "Small Still Life Painting in Oil" at many different venues, including The Woodstock School of Art, Scottsdale Artists' School and Willow Wisp Farm Studios (Asheville, North Carolina). She is represented by numerous galleries, including The Fine Arts Gallery in Bronxville, New York, Horizon Fine Art Gallery (Jackson Hole, Wyoming) and The Crane Collection (Cape Ann, Massachusetts). She was featured in *American Artists'* Still Life Highlights 2005 issue, as well as in their Spring 2006 issue of *Workshop Magazine*. More information about Joyce and her work is available on her Web site, www.joycewashor.com.

METRIC CONVERSION CHART

To convert	to	multiply by
Inches	Centimeters	2.54
Centimeters	Inches	0.4
Feet	Centimeters	30.5
Centimeters	Feet	0.03
Yards	Meters	0.9
Meters	Yards	1.1

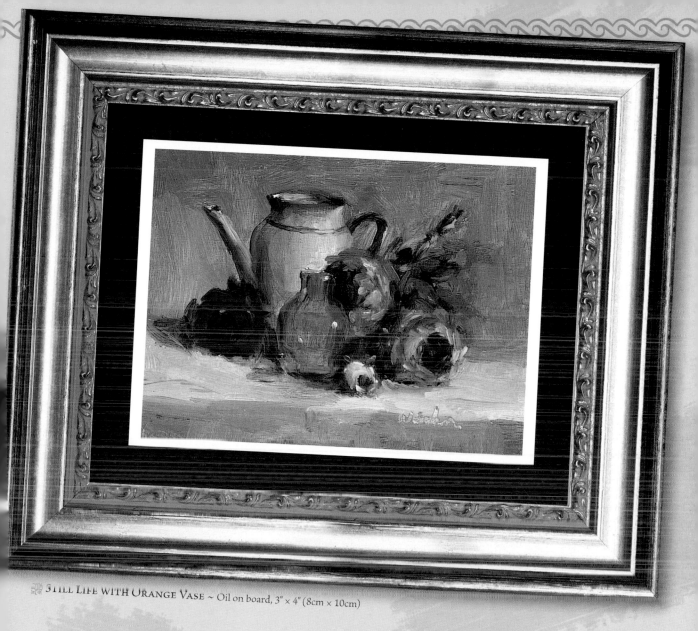

STILL LIFE WITH ORANGE VASE ~ Oil on board, 3″ × 4″ (8cm × 10cm)

Dedication

To my husband, Paul Saltzman, with love and gratitude.

Acknowlegments

I would like to give heartfelt thanks to the instructors and staff at The Woodstock School of Art, Erin Nevius, Wendy Dunning and the many talented people at North Light Books, The Breakfast Club, Al and Tom at On Location Studios for their photographic expertise, Martha Fineman, Richard Kestenbaum, Austin Paul Saltzman, Janet Spiegel, my students and especially to grace, and to those with whom I have experienced its flow.

TABLE *of* CONTENTS

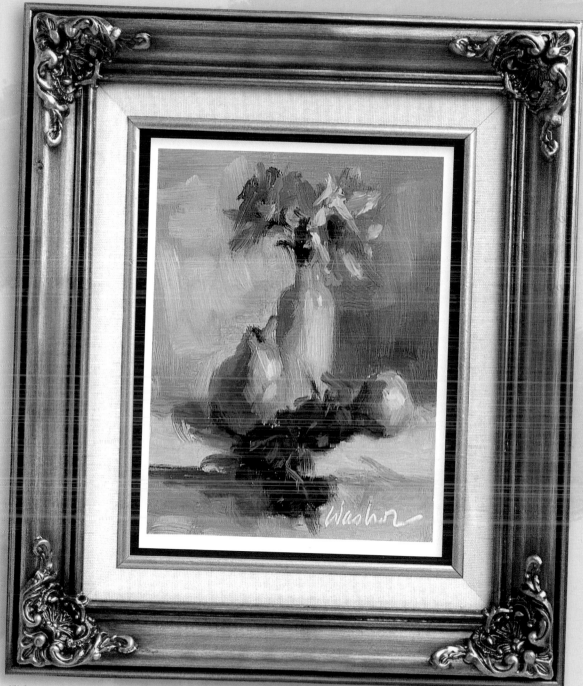

SUNFLOWERS, PEARS, GRAPES ~ Oil on board, 4" × 3" (10cm × 8cm)

Introduction

ABOUT TEN YEARS AGO, I RETIRED FROM A TWENTY-YEAR CAREER AS a textile designer, downsized my living arrangements, began meditating and devoted myself to being a full-time painter. Eventually, I developed a rotator cuff problem in my painting shoulder. It was ironic—once I had time to paint, I couldn't lift my arm.

On an aimless drive one early winter day, I found myself at a local gallery that was having its annual Christmas miniature show. Inspiration struck, and shrinking my compositions became the solution to my physical problem as well as providing the perfect venue for translating my meditation experiences into artful expression. I hold the board and mix paint with my left hand and let my right wrist do the work that my shoulder used to do.

Many of the painting principles that I learned throughout the years didn't make sense to me until I started painting on a smaller scale. Painting small has many advantages, but an artist must still adhere to the principles of painting larger-scale works. Working small gives me more time and energy to devote to each painting, from mixing the right colors to paying attention to the brushwork and composition. In downsizing, I did not want to lose any part of the painting process that I used in completing a 16" × 20" (41cm × 51cm) or 11" × 14" (28cm × 36cm) painting. The small paintings have all the same attention to detail that my larger paintings had. I don't need to choose different objects to paint, but how I paint them has changed. I need to be more decisive with color choices and concentrate on using brushstrokes to define space and forms concisely. This has made my paintings stronger.

There are many other advantages to painting small—supplies last longer, your workspace is more compact (you don't need a large studio), shipping is cheaper, galleries are more likely to give you wall space, it's easier to keep brushes clean, there is less stress on the body, no mediums are necessary so it's healthier and, best of all, since it doesn't take as long to finish a painting the learning curve is shorter.

Whether you find yourself painting small just as an exercise or on a continuing basis, it is my hope that you will find the experience rewarding and that it will add to your knowledge of the painting process. Good things come in small packages!

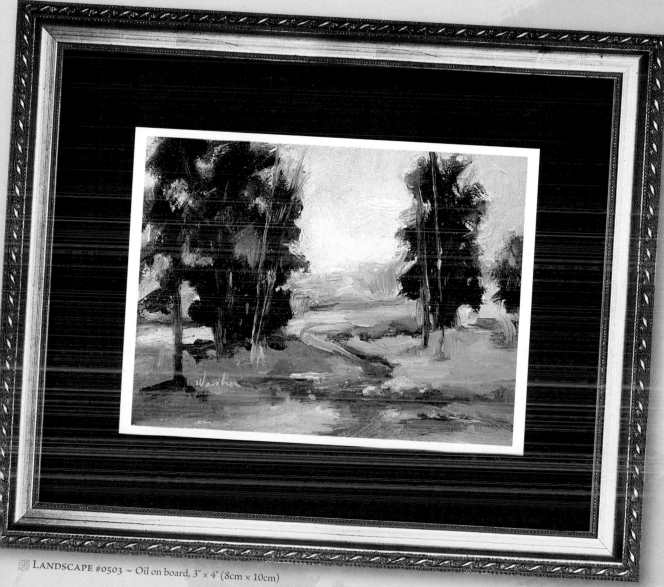

LANDSCAPE #0503 ~ Oil on board, 3" × 4" (8cm × 10cm)

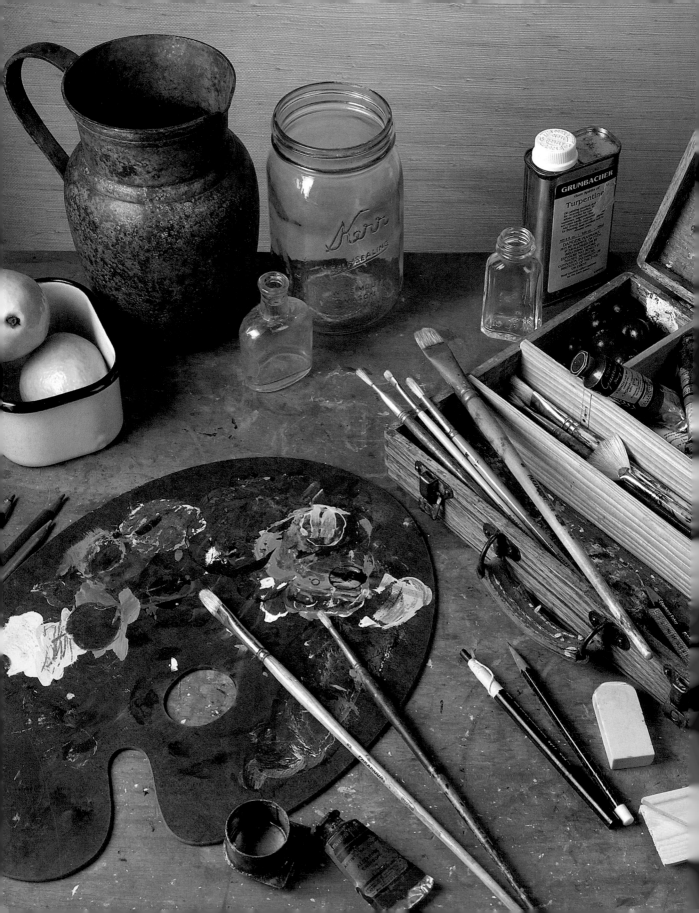

WHAT YOU NEED *to* PAINT SMALL

RECENTLY, ON A FLIGHT COMING BACK FROM TEACHING A WEEK-LONG workshop, it occurred to me that, in essence, making art was like playing one of my grandson Austin's favorite car games: The Opposites Game. I say "big," and he says "small." He says "right," and I say "left."

A composition must have balance; if something is going up, something else must come down. If something comes forward, something else must go back. Opposites carry over into almost every aspect of painting. Brushstrokes can be fast or slow. Edges can be soft or hard. Colors are either warm or cool, bright or dull, light or dark. My small paintings require many color tubes (I use three complementary palettes and buy professional brands), yet very few boards and brushes. Paints are expensive, but boards are cheap. A tube of paint can last up to ten years, but a board is a one-use-only deal.

We are fortunate to live in the twenty-first century, where a plethora of art supplies is available. Establishing your painting supplies is a combination of taking advice from painters and fitting that advice to your particular needs and tastes. Discard and assimilate. Oops! There are those opposites again.

Paints: Choosing Your Colors

One of the many advantages of creating small paintings is that it makes using a professional grade of paint more affordable—significantly less paint is needed than when you create larger works. Just for fun I have noted on some tubes the date of purchase and am consistently surprised at how many years have passed. You'll always want to use the highest grade of paint that your budget can afford. Painting poses enough to think about without adding the problem of poor paint quality.

Complementary Colors

The complementary colors are those colors opposite each other on the color wheel. Yellow and purple, red and green, and orange and blue are complementary colors. When used side by side, they will vibrate. When equally mixed together, they create beautiful neutral grays. I use only palettes comprised of complementary colors in my work, and it helps create harmonious, united paintings. (More on complementary colors in chapter two.)

Chrome Green
Rodney Georgian

Cobalt Blue
Winsor & Newton

Naples Yellow
Winsor & Newton

Permanent Rose
Winsor & Newton

Sap Green
Winsor & Newton

Violet Gray
Old Holland

Purple Madder
Winsor & Newton

The Colors You'll Need
These are the paints that I use most often in my work.

The Complementary Color Wheel
Colors opposite each other on the color wheel are complements—red and green, purple and yellow, and blue and orange. Using complementary colors in your paintings reduces the chance that you will mix muddy colors and lends harmony to your composition.

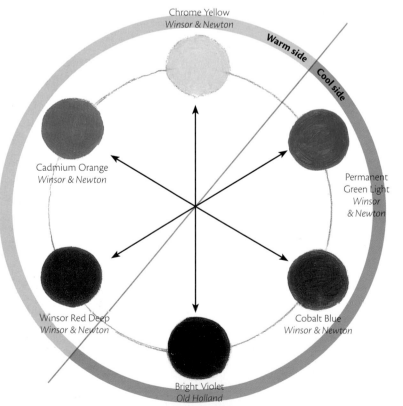

Chrome Yellow
Winsor & Newton

Warm side

Cool side

Cadmium Orange
Winsor & Newton

Permanent Green Light
Winsor & Newton

Winsor Red Deep
Winsor & Newton

Cobalt Blue
Winsor & Newton

Bright Violet
Old Holland

Brushes: The Tools of the Trade

Generally, the brushes I use are filberts (flat brushes with rounded tips), rounds, ovals and brights (short, flat brushes). No. 00s come only as rounds. You should experiment with all the different brushes available, but personally, I find that filberts best express the feelings I'm aiming for. Filberts can be used on their sides for thin strokes or flat for broader ones.

I recommend brushes made of hog bristle. Hog hair brushes are stiff enough to work on boards (or canvas) and hold a good amount of paint. For small paintings, two no. 00 rounds and a couple of nos. 1 and 2 filberts will fit your needs nicely. The no. 2s are good for blocking in color (the first stage of painting), the no. 1s are for medium-sized color notes, and the no. 00s are for the smallest details, like highlights. Two of each size is suggested so you can have one brush for light colors and one for darks in each size.

Remember to use the largest brush you are comfortable with for each passage of the painting. This will keep the painting from breaking up into individual strokes instead of clean, clear color statements.

If you've ever been reprimanded by an art teacher for using a brush that's too small for what you're doing, smaller paintings may be just the answer for you. I usually used big enough brushes to satisfy my teachers, but the brushes never seemed to manipulate the paint the way I wanted them to. When I started doing smaller paintings, I remember smiling to myself and thinking, "Well, instead of using a larger brush I can use a smaller canvas, and proportionately it will even out." A no. 2 brush is ¼" (6mm). Using it on a board that is 3½" (9cm) wide is like using a 2" (5cm) brush on a canvas 28" (71cm) wide. Using small brushes loaded with paint makes for a luscious painting. This is one of the major factors that gives my paintings their distinctive look.

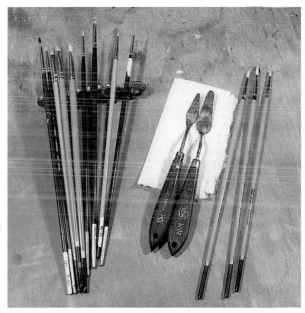

Photo by Jerry Landi

USING A PALETTE KNIFE TO MIX COLORS

Use a 2" (5cm) palette knife to mix your colors on the palette. Using a palette knife to mix colors saves wear and tear on your brushes. It makes it easier to get just the right amount of paint you need for a mixture, and the colors will be cleaner.

Photo By Jerry Landi

Brushes
These are the brushes I've accumulated over the years and use frequently (left to right): no. 1 round (Art Tec), no. 0 round (Silver Bristlon), no. 1 flat signet (Robert Simmons), no. 2 flat signet (Robert Simmons), no. 2 round signet (Robert Simmons), no. 0 round (Silver Bristlon), no. 0 round (Silver Bristlon), no. 00 round signet (Robert Simmons), no. 0 round (Silver Bristlon), Atrium no. 21 palette knife, RGM plus no. 5 palette knife, no. 1 flat signet (Robert Simmons), no. 2 flat signet (Robert Simmons), no. 0 round (Daler-Rowney).

Prepare Your Surface

*I*paint on untempered (oil-free) masonite. It can be cut down to any size, even after you've painted on it. My paintings are 2⅞" × 3¾" (7cm × 10cm). The sight size of my paintings is 2½" × 3½" (6cm × 9cm). (Sight size is what you see after you've framed an image.) I leave room in the composition for the lip of the frame, or the rabbet, to overlap the painting. I used to leave this border unpainted, but I've found that, for photography purposes, it's best to paint to the edge of the board even though it won't all show when framed. You will have a slide or digital image that's more professional: it's a cleaner, neater presentation for entrance in competitions or for gallery representation.

Priming Your Surface with Gesso

Before I paint, I always coat my masonite boards with gesso. Gesso prevents the oils from being absorbed into the board. Use it to help conserve your paints.

As with paints, it's best to use a good brand of gesso. Cheaper brands may have more water, so you just have to use more of the product. I use Goldens.

Brush it on with a 1" (25mm) watercolor brush (I use a watercolor brush because gesso is water-based). If the consistency is too thick to maneuver, add a tiny bit of water. The thicker the solution is, the better the coverage will be.

Find the Sight Size
Draw guidelines on your board so you know where the frame will cover the painting.

Preparing Your Board
Before you begin painting, use a 1" (25mm) watercolor brush to coat your masonite board with thick gesso.

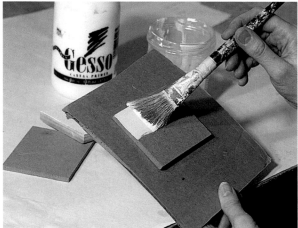

Avoid a Mess
Tape your board to a small piece of cardboard when applying gesso. This way, the board won't shift and you won't wind up with gesso all over your hands.

Create Your Own Palette

aking your own palette gives you a certain measure of freedom with your colors. You can make your palettes as big or small as you want, and plus, it's cost effective!

I suggest using freezer wrap paper taped over an 11½" × 16" (29cm × 41cm) masonite board. Mixing on white paper and then painting on a white surface makes it easier to match colors accurately, since both bases are the same color. Another advantage is easy clean-up—you can just throw the palette away when you're done with it, eliminating the need to clean it with turpentine for reuse.

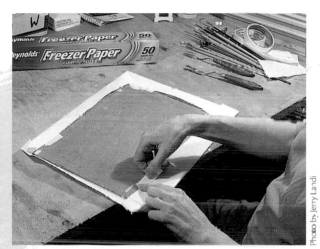

Photo by Jerry Landi

1 CUT AND TAPE THE PAPER TO THE BOARD

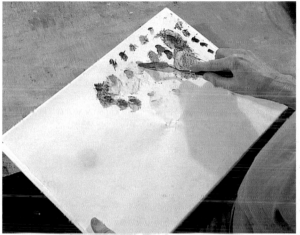

Photo by Jerry Landi

2 PALETTE IN USE

Controlling the Light in Still Lifes

*A*shadow box is merely a section of an ordinary cardboard box, but it serves two important functions: It keeps unwanted light off of still life objects, and it acts as a frame to support the background fabric.

Cut away two sides of a corrugated box (12" × 12" × 18" [30cm × 30cm × 46cm]). Using a lamp with a flexible arm, angle the light onto the objects to your specifications. It's generally best to light the objects so that approximately half of them are in light and

the other half are in shadow. Lighting is crucial in showing dimension and adds great excitement to the painting. It also sets the mood. As painters, what we're really painting is light and the effect it has on our subjects.

Be sure to set the shadow box up so that any outside light is coming from the same direction as the lamp light. A combination of natural light and lamp light works well—it helps you see the colors of the objects and aids in judging colors while mixing them.

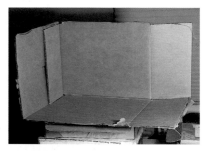

Making A Shadow Box
Use an ordinary cardboard box to construct your shadow box. Use books or other boxes underneath to adjust the height.

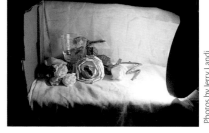

Photos by Jerry Landi

Set Up Your Still Life
Putting your shadow box on a table will allow you to be very close to your subjeccts and make it easier to see and match colors.

Get the Right Light
Place the light close to the objects in order to create interesting shadows. Be sure to clearly depict the shadow side of your subjects—they will look more three-dimensional when there is a marked difference between light and dark.

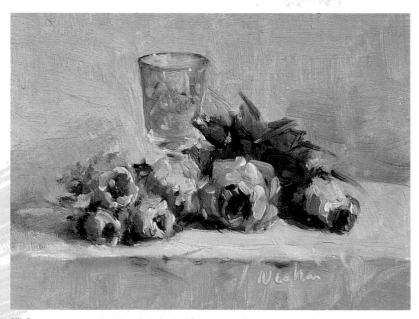

STILLNESS ~ Oil on board, 2⅞" × 3¾" (7cm × 10cm) ~ Collection of the artist

Using Fabric as a Backdrop

Fabrics act like a stage support for your still lifes. They lend your subjects the most advantageous setting possible. They can make oranges look even more orange, roses more red and pears more yellow. The fabrics (both for backdrops and tabletops) help set the mood of the painting as well as the color feeling. I find it best not to complicate the backgrounds with textured or patterned fabrics, since my paintings are so small.

Use about ¾ of a yard (.7 meters) of fabric for the background and the tabletop. Sort your fabrics by palette, as you have done with your paints. Your choice of fabric will influence which color palette you will use for the painting, and it will set the stage for the center of interest—the still life objects.

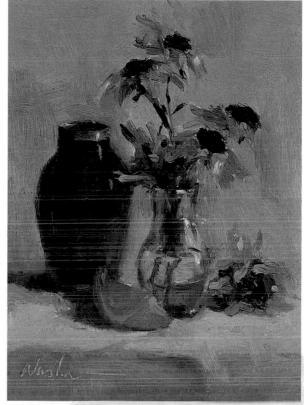

Blue Fabric Emphasizes Orange Subjects
The orange slice easily dominates this painting when a complementary blue backdrop is used.

BLACK-EYED SUSANS ~ Oil on board, 3¾" × 2⅞" (10cm × 7cm)
~ Collection of Bill and Judith Paley

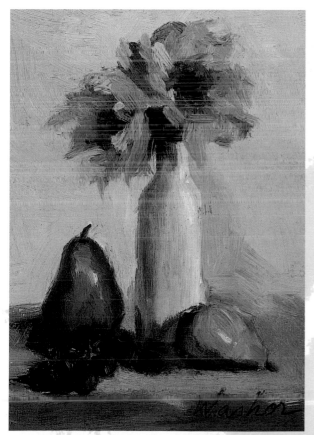

Purple Fabric Makes Yellow Glow
The dark purples of the fabric, as well as the purple in the shadows, make the yellow of the pear glow.

SUNFLOWERS AND TWO PEARS ~
Oil on board, 3¾" × 2⅞" (10cm × 7cm)
~ Collection of the artist

Green Brings Out Your Reds

The soft green of the fabric enhances the range of reds in the grapes and flowers.

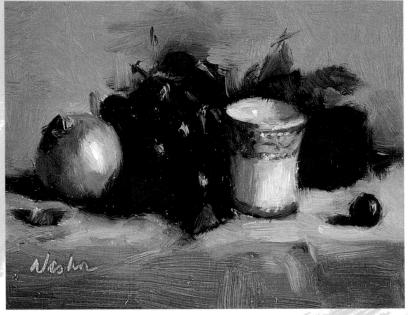

� GRAPES, ROSES AND GOLD-RIMMED CUP ~ Oil on board, 3¾" × 2⅞" (10cm × 7cm) ~ Collection of Callie Brown

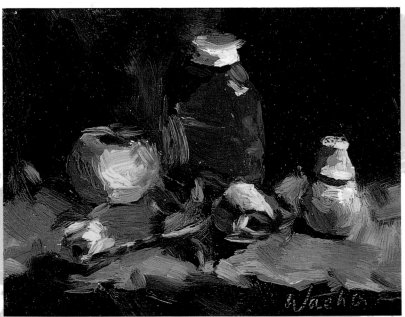

Using Dark Fabrics to Emphasize Light Subjects

Choosing dark fabrics for your background gives your paintings a dramatic effect. The lightest colors are emphasized because of the contrast.

✲ HONEY JAR AND SALT SHAKER ~ Oil on board, 3¾" × 2⅞" (10cm × 7cm) ~ Collection of the artist

More Tips and Supplies

Here are a few more helpful suggestions for preparing to paint.

Organizing Your Work Station

This can be a challenge, particularly if you've set up a still life composition to be studied as you paint. You can place your composition on a far corner of your work table, leaving the remaining area for you and your supplies.

Another helpful trick is to cut down on the space you need for your painting surface. I find my palette takes up most of the room on my table. To allow for as much space as the palette needs, I either mount the board on a piece of cardboard (with rolled up masking tape) or use the tape to combine it with another board so that it's thick enough to paint on without getting my hands painted as well. If I'm working on a board that is ¾" (2cm) thick, I simply hold the board on the edges when I paint. If the board is ½" (1cm) or ¼" (6mm), I use the cardboard.

Photo by Jerry Landi

Setting Up Your Work Area
If you've set up a still life composition, placing it on the far corner of your work table can free up space for your supplies.

Photo by Jerry Landi

Cut Down On Space
Since your palette likely takes up most of the room on your work table, taping your board to a piece of cardboard or another board can allow you to hold the painting as you work and not get paint all over your hands. Say goodbye to easels forever!

Use Paper Towels for Clean-Ups

It may seem obvious, but I've found that using paper towels is the best way to keep my palette knife clean. This is important, because a clean palette knife will yield clean color mixtures. I tear the paper towels into small sections and toss them after a few clean-ups. This helps to keep me from grabbing a clump of paper towel and getting my hands dirty with old paint.

Varnish to Enhance Color

Using varnish brings the dried pigments in your painting back to their original, rich color. Try many different varnishes to find which one you like best, but I recommend spray varnish—it goes on more evenly when sprayed than when brushed on. And no reason to have to clean another brush! I use Krylon Damar Varnish.

Read all of the directions on the can (which should tell you to wait to apply until the painting is completly dry), and always apply varnish in a well-ventilated area—preferably outdoors.

Photo by Jerry Landi

Cleaning Your Palette Knife
Keeping a clean palette knife will result in cleanly mixed colors.

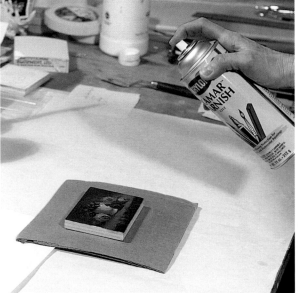

Photo by Jerry Landi

Using Varnish
Varnish brings dried pigments back to their original luster. Be sure to always use it in a well-ventilated area.

Use a Brush Cleaning Solution

Though old-fashioned soap and water will work, I recommend finding a brush cleaning solution that you like. These solutions are good not only for cleaning brushes, but also for clothes that have been stained with oil paint. I use "The Masters" Brush Cleaner and Preserver.

☙ MY WORK AREA ❧

See how small it can be!

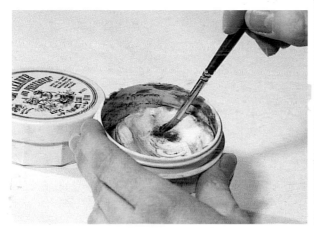

Using A Brush Cleaning Solution

Turpentine isn't necessary to clean such small brushes, but using a brush cleaning solution can be great. It's not as dangerous as turpentine but is just as effective, and you can also use it to remove those unsightly splashes of oil paint on your clothes.

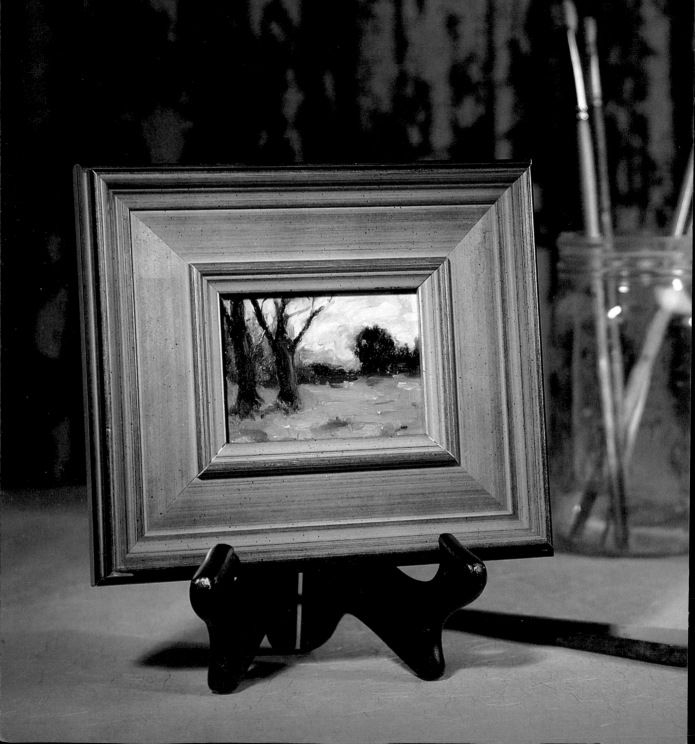

~Two~
the PROPERTIES
of COLOR

PAINTING SMALLER HAS MADE IT EASIER FOR ME TO MIX COLORS correctly. There is less pressure—fewer supplies are needed, which saves money, plus there's more time to do the mixing since the paintings are done quickly. Small paintings have also taught me the art of careful color observation. An object may not be immediately recognizable just by its size, so the color has to be representational to help identify it. In painting, it is important to exaggerate color in order to translate the world onto a board or canvas. In doing small paintings, this is even more necessary because of size limitations. Even though the paintings are small, they can have great carrying power. (Carrying power is the ability to see the image from across the room.)

Using only two families of color (complementary colors) will naturally give your paintings strength and harmony. An infinite number of colors can be mixed with the hues in complementary palettes.

℘

Primary Colors

Colors, and the mixtures that can be made from them, can be broken down into three basic categories: primary, secondary and tertiary colors. Primary colors are the three basic colors—red, yellow and blue—that can be mixed to produce any other color.

Primary Colors
The primary colors are red, yellow and blue. They are the basis of all other colors and can be mixed to create any hue.

Painting with Primary Colors
This painting was done with the red/green palette, but relies heavily on the interplay of the red, yellow and blue—red takes center stage, while the blue recedes and the yellow complements.

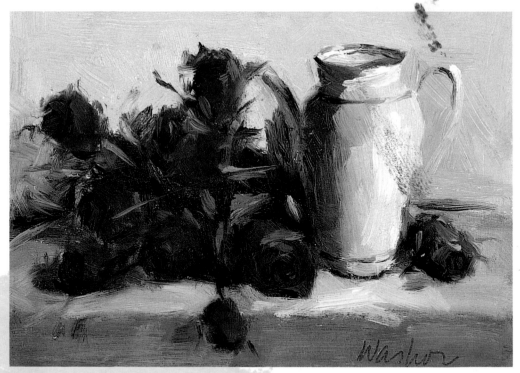

✻ GOLD RIMMED VASE AND ROSES ~ Oil on board, 2½" × 3½" (6cm × 9cm) ~ Collection of Martha Fineman

Secondary Colors

Secondary colors are produced by mixing any two primary colors. They appear between the primaries on the color wheel.

Secondary Colors

The secondary colors are made by mixing any two primary colors. Orange is made from yellow and red, green is made from blue and yellow and purple is made from blue and red.

Painting with Secondary Colors

All the secondary colors—orange, purple and green— were used to help capture this winter scene. You can mix these hues with the orange/blue palette.

JANUARY SNOW ~ Oil on board, 2⅞" × 3¾" (7cm × 10cm) ~ Collection of the artist

Tertiary Colors

Tertiary colors are colors mixed from equal amounts of a primary and an adjacent secondary. They are also known as intermediates.

Tertiary Colors

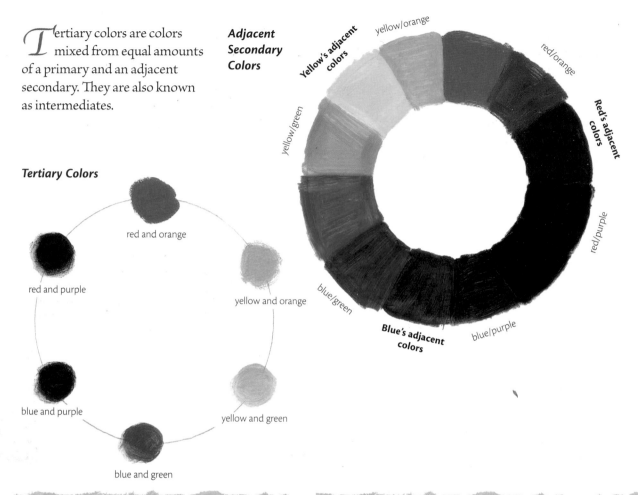

Adjacent Secondary Colors

Yellow's adjacent colors

yellow/orange

red/orange

yellow/green

Red's adjacent colors

red/purple

blue/green

blue/purple

Blue's adjacent colors

red and orange

red and purple

yellow and orange

blue and purple

yellow and green

blue and green

❧ ANALOGOUS COLORS ❧

Colors closely related along the color wheel are called analogous colors. They can be any three adjacent primary, secondary and tertiary colors. For example, yellow, yellow-green and green are analogous. Using these related colors can bring harmony to a painting.

Nature provides the perfect opportunity to use analogous colors—especially during autumn. This painting was done using the red/green palette. Mixtures of yellow-orange, orange-red and orange were used to make a warm, harmonious painting.

LANDSCAPE COMPOSITION ~ Oil on board, 3" × 4" (8cm × 10cm) ~ Collection of the artist

Using Complementary Palettes

s mentioned in chapter one, complementary colors are those opposite one another on the color wheel. As I use only complementary colors in my paintings, I use one of three palettes for each piece. Which of the three depends on the colors and mood in the scene or still life.

I learned the complementary palette theory from my teacher HongNian Zhang at the Woodstock School of Art. It is based on the ancient Chinese dualistic philosophy of yin and yang, which is the study of the balance of opposites. Until I began using the complementary palette, more often than not my color mixtures turned muddy and unusable. Using the complementary palette has made it much easier for me to mix harmonious and beautiful colors.

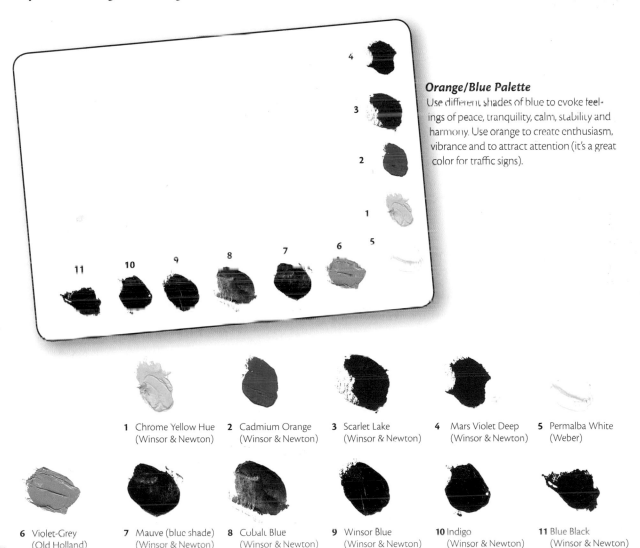

Orange/Blue Palette

Use different shades of blue to evoke feelings of peace, tranquility, calm, stability and harmony. Use orange to create enthusiasm, vibrance and to attract attention (it's a great color for traffic signs).

1 Chrome Yellow Hue (Winsor & Newton) **2** Cadmium Orange (Winsor & Newton) **3** Scarlet Lake (Winsor & Newton) **4** Mars Violet Deep (Winsor & Newton) **5** Permalba White (Weber)

6 Violet-Grey (Old Holland) **7** Mauve (blue shade) (Winsor & Newton) **8** Cobalt Blue (Winsor & Newton) **9** Winsor Blue (Winsor & Newton) **10** Indigo (Winsor & Newton) **11** Blue Black (Winsor & Newton)

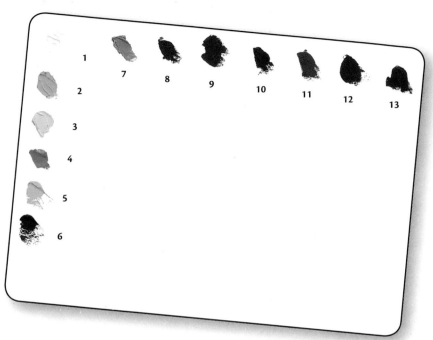

Yellow/Purple Palette

Yellows impart joy, optimism, sunshine, betrayal, gold and philosophy. Purple reprents royalty, spirituality, wisdom and enlightenment.

1 Light Yellow
(Old Holland)

2 Chrome Green Hue
(Rowney Georgian)

3 Chrome Yellow Hue
(Winsor & Newton)

4 Cadmium Yellow
Deep (Grumbacher)

5 Naples Yellow Hue
(Winsor & Newton)

6 Raw Umber
(Winsor & Newton)

7 Violet-Grey
(Old Holland)

8 Magenta
(Winsor & Newton)

9 Bright Violet
(Old Holland)

10 Ultramarine Violet
(Winsor & Newton)

11 Mars Violet Deep
(Winsor & Newton)

12 Purple Madder
(Winsor & Newton)

13 Blue Black
(Winsor & Newton)

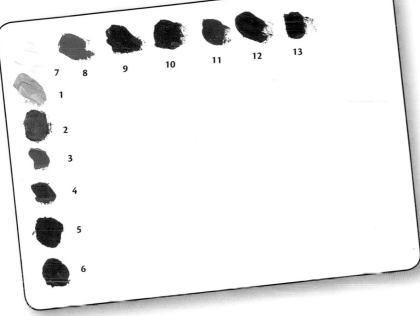

7 8 9 10 11 12 13

1

2

3

4

5

6

Red/Green Palette

Use reds to portray love, danger, speed and of course, warmth. Use greens to represent health, renewal, youth, jealousy and envy.

1 Chrome Green Hue (Rowney Georgian) **2** Sap Green (Winsor & Newton)

3 Permanent Green Light (Winsor & Newton) **4** Winsor Green (Winsor & Newton) **5** Permanent Green Deep (Winsor & Newton) **6** Raw Umber (Winsor & Newton) **7** Permalba White (Weber) **8** Cadmium Orange (Winsor & Newton)

9 Winsor Red Deep (Winsor & Newton) **10** Permanent Rose (Winsor & Newton) **11** Indian Red (Winsor & Newton) **12** Purple Madder (Winsor & Newton) **13** Blue Black (Winsor & Newton)

HOW TO REMEMBER ❧ COMPLEMENTS ❧

As previously discussed, the colors opposite each other on the color wheel are complements. An easy way to remember a complement is to use the mixture of the two remaining primary colors. For example, to find the complement of yellow, find the mixture of red and blue. When you get purple, simply look at the color wheel and you will see that across from purple is yellow—its complement.

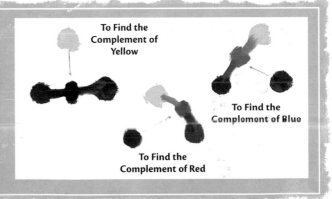

To Find the Complement of Yellow

To Find the Complement of Blue

To Find the Complement of Red

Creating Vibrancy with Complements

A color is most vibrant when placed next to its complement—it will vibrate with intensity and really bring your painting alive. Use this trick to create intensity and draw the viewer's eyes to your focal point.

Add Vibrancy with Complements

To make a color stand out from a painting, place it next to its complement.

Using Values to Establish Your Focal Point

This blue pitcher is surrounded by objects in different shades of orange, its complement. The placement of these colors clearly defines the pitcher as the focal point.

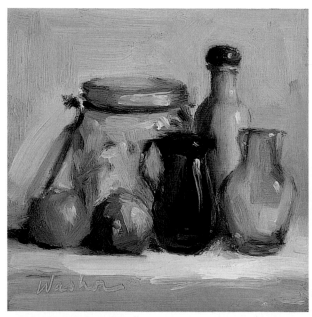

🔆 BLUE PITCHER ~ Oil on board, 3" × 3" (8cm × 8cm) ~ Collection of the artist

The Importance of Neutral Colors

Neutral colors provide the setting for brighter colors. Your painting will be totally confusing if too many bright colors are used. There need to be places in the composition for the viewer's eyes to rest. Seeing too many bright colors in a painting is like going to a show or movie where all of the actors are talking at once. Someone needs to listen.

When mixed together, complementary colors yield beautiful neutrals and grays. Complements do not make muddy mixtures, and much more interesting shades will be created than if you use paint straight from the tube. I always feel as if my painting doesn't really get going until I've mixed some beautiful neutrals. I have heard these beautiful colors referred to as "color neutrals."

The use of warm or cool neutrals will help express the warmth or coolness of a scene (more on color temperature on page 33). It will set the mood of the painting. I suggest seeing how many neutrals you can mix with each of the three complementary palettes. Try mixing equals parts of both complements, then vary the percentages to create warmer or cooler hues.

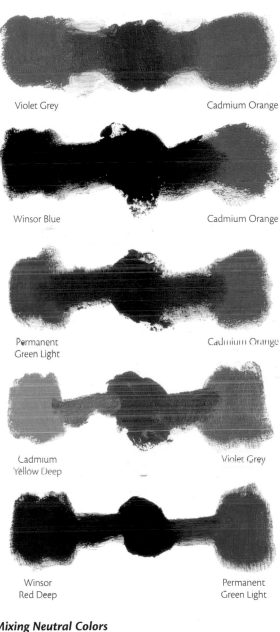

Violet Grey Cadmium Orange

Winsor Blue Cadmium Orange

Permanent Green Light Cadmium Orange

Cadmium Yellow Deep Violet Grey

Winsor Red Deep Permanent Green Light

Mixing Neutral Colors
These are some examples of neutrals you can mix with complementary colors.

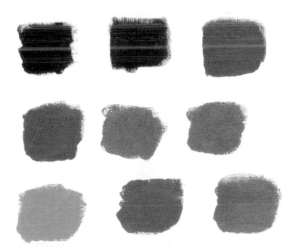

Create Beautiful Grays
Here are some lovely grays mixed with complementary colors.

Hue and Intensity

There are four basic characteristics to a color: hue, intensity, temperature and value.

Hue

Hue is the name of a color, such as red, yellow, blue or green. Hues are also used to describe how much a color lends itself to another color. For example, a color can be termed "red-purple" or "red-orange" if that red has a purple or orange cast to it.

Notice that the colors are described using adjacent colors on the color wheel. Red is next to both purple and orange.

Intensity

Intensity, or saturation, is how bright or dull a color is. The closer a color is to the pure hue in the tube, the higher its intensity. The more gray a color is, the lower its intensity. A color is grayed by mixing it with its complement. Even adding a small amount of a complement gives you a less intense color. Mixing equal amounts of complementary colors results in a beautiful neutral.

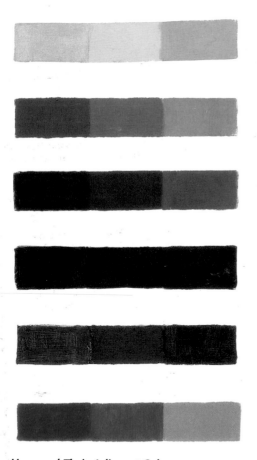

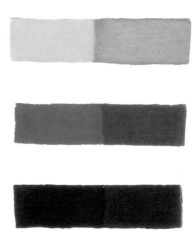

Color Intensity
The colors on the left are significantly more intense than those on the right, which have been mixed with their complement.

Hues and Their Adjacent Colors
Hue is a term that describes the name of a color, but it can also be used to describe a mixture of two adjacent colors, such as yellow-green. The first color mentioned (in this instance, the yellow) has the higher percentage in the mixture—it will loook more yellow than green.

Temperature

Temperature is the warmness or coolness of a color. Generally, the warm colors are reds, oranges and yellows, and the cool colors are greens, blues and violets.

However, there are warm and cool hues in the same color family. Red can be either warm or cool—a warm red is Cadmium Orange and a cool red is Permanent Rose. Purple Madder is an even cooler red. A warm blue is Mauve (Blue Shade). A cool blue is Winsor Blue (Green Shade). Cadmium Yellow Deep is a warm yellow and Chrome Green is a cool yellow.

It's important to recognize warm and cool colors within their own families. For instance, if you want to mix a warm purple, you need to know which reds and blues are warm. If you want a cool purple, you need to use the cool hues.

Warm and Cool Colors in the Same Family

Generally reds are warm, but there are definitely cool variations. These reds get cooler as they go to the right.

Warm Cadmium Orange
(Winsor & Newton)

Winsor Red Deep
(Winsor & Newton)

Cool Permanent Rose
(Winsor & Newton)

Cool Purple Madder
(Winsor & Newton)

WARM COLOR CHART

Light Yellow
(Old Holland)

Chrome Yellow Hue
(Winsor & Newton)

Naples Yellow Hue
(Winsor & Newton)

Cadmium Yellow
Deep (Grumbacher)

Cadmium Orange
(Winsor & Newton)

Scarlet Lake
(Winsor & Newton)

Permanent Rose
(Winsor & Newton)

Magenta
(Winsor & Newton)

Purple Madder
(Winsor & Newton)

Indian Red
(Winsor & Newton)

Mars Violet Deep
(Winsor & Newton)

COOL COLOR CHART

Chrome Green Hue
(Rowney Georgian)

Sap Green
(Winsor & Newton)

Permanent Green Light
(Winsor & Newton)

Winsor Green
(Winsor & Newton)

Permanent Green Deep
(Winsor & Newton)

Raw Umber
(Winsor & Newton)

Violet-Grey
(Old Holland)

Cobalt Blue
(Winsor & Newton)

Winsor Blue
(Winsor & Newton)

Mauve (blue shade)
(Winsor & Newton)

Ultramarine Violet
(Winsor & Newton)

Bright Violet
(Old Holland)

Indigo
(Winsor & Newton)

Blue Black
(Winsor & Newton)

Value

Value is the relative lightness or darkness of a color. Generally, darker colors have a lower value and lighter colors have a higher one.

Values change according to the colors around them. For instance, a gray might look very dark on a white background, but very light on a dark background. Value is easier to see in black and white due to the stark contrasts, and all colors can be converted to a gray scale. For instance, in the red family, maroon has a low value and pink has a high one.

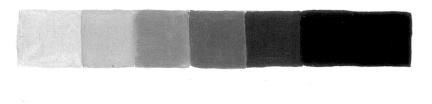

Using a Gray Scale to See Values
It's easier to see values in black and white than it is in color, since black and white are in such contrast. It can help get the values right in your paintings if you do a black and white value sketch before applying color.

Value Chart
Here's a value chart detailing the range of values in the primary and secondary colors. Different values can be used to create shape, form and dimension by bringing objects forward or letting them recede into the background.

Using Value to Create Three Dimensions

Value is a good tool for creating three-dimensions in your paintings. Colors with lighter values tend to come forward, helping you establish focal points. Darker values naturally recede into the background, so you can use darker values to define the edges and give your subjects shape.

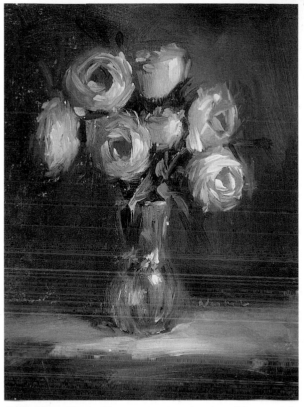

Using Value to Establish Shape

The values in this painting, as in most paintings, are crucial. The dark red of the background recedes, clearly bringing the flowers forward. The change in value between the vase and the background gives the vase its shape.

🌸 ROSES IN CLEAR VASE ~ Oil on board, 3⅛" × 2⅓" (9cm × 6cm)
~ Collection of the artist

Using Value to Lead the Eye

In this painting, the lighter values of the grapefruit and the pink rose draw the viewer's eye to them.

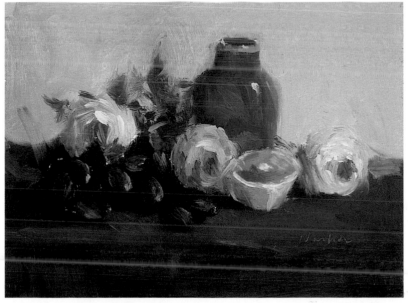

🌸 ROSES WITH GRAPEFRUIT ~ Oil on board, 3½" × 2½" (6cm × 9cm) ~ Collection of
Lorraine Schorr

Mixing Colors

Using a palette knife to mix colors is easier than using a brush. It makes it possible to get an exact amount of paint from the pile of paint into the mixture and helps keep the colors pure. It also preserves your brushes—mixing paint with them can split the bristles.

Keep looking at the object, landscape or photo that you are painting as you mix your colors. I find a strange phenomenon occurs the longer I look at the subject. It is like what happens in a dark theatre. It takes time for your eyes to adjust, but then you are able to see so much more. The longer you spend looking, the more you see and the more sensitive you become to the nuances of temperature, value and intensity.

Add new colors in very small amounts when mixing. If you add too much paint and the color is too far off, discard the pile and start again but save the pile for future use—ninety percent of the time I find that it's applicable in another part of the painting. This is another advantage of the complementary palette. Colors are so harmonious that even mistakes are useable.

Remember to wipe the palette knife clean when mixing very clean, bright or dark colors. This is not necessary when mixing more neutral colors. In fact, it can sometimes be helpful to transfer some of the previous color to the new color. It adds to the cohesiveness of the painting.

Take as much time as necessary to match colors, especially during the initial blocking in. I can spend thirty minutes on one color and feel it's time well spent. Getting the right colors in the beginning of the painting is important, since the subsequent colors are going to be mixed based on their relationship to these initial colors.

Mixing Paints
When mixing the colors for a painting, be sure to always use a palette knife. The size of half a dime is a good amount of paint to use for mixing.

Photo by Jerry Landi

MAKING A COLOR CHART
⇒ FOR REFERENCE ⇐

Color charts for each of the three complementary palettes can be very useful. Use freezer paper (the same as you used for your palette). Make 1" (3cm) to 2" (5cm) squares using a ruler, and explore what colors result when your most frequently used paints are mixed together. It will acquaint you with the variety of colors that can be mixed from the tube colors. Any one of the color mixtures can be explored more fully by using varying amounts of the mixture colors or introducing any other color from the palette. Be careful not to use a color from another palette, or chances are the mixture will turn muddy. Keep these sheets for reference to use when searching for a color. This is an example of a color chart for my yellow/purple palette.

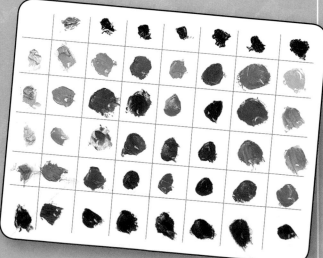

Darken a Color Without Black

Darken a light color by mixing it with a darker color in the same family or a darker complementary color. For example, to make Winsor Red Deep darker, mix it with Purple Madder (a darker color in the same family) or a bit of Permanent Green Deep (a complementary color). Cobalt Blue can be darkened by mixing it with Winsor Blue or its complement, Mars Violet Deep. Use Mars Violet Deep or a bit of Cobalt Blue to make a beautiful dark orange. Chrome Yellow is darkened with Raw Umber or Ultramarine Violet. Bright Violet needs Permanent Green Deep to make it darker. Bright Violet has a very red cast and needs a green complement.

Lighten a Color Without White

Instead of adding white to a color to make it lighter (white tends to make colors chalky and neutral), mix it with a lighter color of the same cast. A cast is a color in the same color family. It has a trace of the same hue. Make Winsor Red Deep lighter by using Cadmium Orange. Make Permanent Green Light lighter by using Chrome Green. Cobalt Blue will lighten with Violet Blue-Grey. Cadmium Orange will change using Chrome Yellow. Chrome Yellow needs Light Yellow and Bright Violet needs Violet Grey.

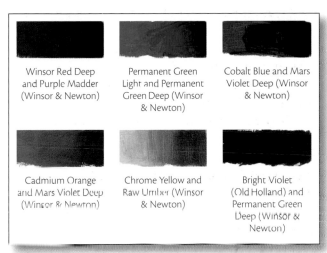

Winsor Red Deep and Purple Madder (Winsor & Newton)

Permanent Green Light and Permanent Green Deep (Winsor & Newton)

Cobalt Blue and Mars Violet Deep (Winsor & Newton)

Cadmium Orange and Mars Violet Deep (Winsor & Newton)

Chrome Yellow and Raw Umber (Winsor & Newton)

Bright Violet (Old Holland) and Permanent Green Deep (Winsor & Newton)

Make Lovely Darks

Instead of darkening a color by adding black, which can dull it, mix it with a darker color in the same color family or with a darker complementary color.

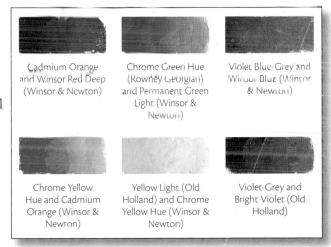

Cadmium Orange and Winsor Red Deep (Winsor & Newton)

Chrome Green Hue (Rowney Georgian) and Permanent Green Light (Winsor & Newton)

Violet Blue-Grey and Winsor Blue (Winsor & Newton)

Chrome Yellow Hue and Cadmium Orange (Winsor & Newton)

Yellow Light (Old Holland) and Chrome Yellow Hue (Winsor & Newton)

Violet-Grey and Bright Violet (Old Holland)

Create Brilliant Lights

Instead of using white to make a color lighter, which can neutralize the color and make it chalky, add in a lighter hue from the same family.

~*Three*~

Three-Dimensional
COMPOSITION

CHAPTER TWO DEALT WITH DETERMINING HOW TO CHOOSE THE correct color. This chapter will deal with choosing the correct place to put that color. I remember one of my teachers saying, "All you have to do is mix the right color and put it in the right place." It's not so hard to do that when following the basic painting principles for composition.

I paint still lifes and landscapes almost exclusively, and there are two main differences between them. In landscape painting, you need to create a sense of deep space and be responsive to the changing light conditions. In still life painting, you are in control of the light source and your studio environment. Though the two are dissimilar in this way, many times while working on a still life I have found myself thinking of landscapes, and when working on a landscape, thinking of still lifes.

Think of the backdrop in a still life as the sky, the tabletop as the ground, and the objects as trees and/or structures. This will add to the feeling of depth in your small still lifes. While doing a landscape I remind myself that it is necessary to render the forms (trees, bushes) three-dimensionally in the same manner as bottles and flowers. Whether setting up a still life or trying to capture the ever-changing beauty of nature, the same rules of composition, dimension and perspective apply.

ß

Selecting Subjects for a Still Life

It is important to decide what to leave out as well as what to leave in when choosing subjects for a still life. Be sure to use only objects that serve a pictorial purpose—anything that supports the principles of painting. Does it help create dimension, perspective or lend to the color harmony? Does it add to the center of interest or the variety, balance or unity of the composition? Does it add to the value structure or the movement of the composition?

Small bottles, cups, vases, creamers (the size they use in restaurants is good), glasses, silver sugar bowls, copperware (for the color), grapes, onions, garlic, lemons, oranges and small flowers and buds are some of my favorite items for still lifes. Grapes are good because you can use as many or as few as you need. Slices can be cut from oranges and lemons to be used in the foreground as the smallest objects in the composition, and you can angle the light so that it goes through the slices and reflects color onto the tabletop. Miniature roses, azaleas and daisies are flowers that can be placed in small vases or laid horizontally in the foreground of your compositions. As you accumulate objects for your still life paintings, keep in mind that you will need subjects of different sizes, shapes and colors to make your compositions interesting.

Photo by Jerry Landi

Collecting Subjects
Look for different colors, sizes and textures when you're collecting objects to be used in still lifes.

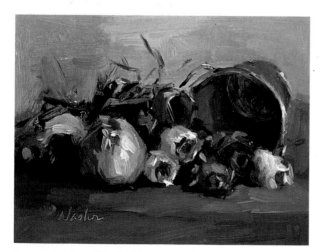

Arranging Small Still Lifes
For still lifes in a horizontal format, select objects that are eight inches across or less. Look for variety in size, color and shape. For vertical still lifes, don't use objects any taller than twelve inches.

❊ OVERTURNED VASE ~ Oil on board, 2⅞" × 3¾" (7cm × 10cm) ~ Collection of the artist

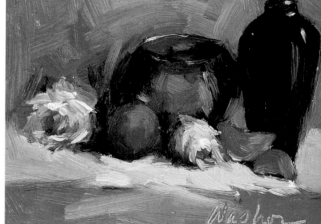

Compose in Three Dimensions
Spend as much time as you need to set up your still life model—you're actually composing the painting three-dimensionally.

❊ COMPOSITION IN ORANGE AND BLUE ~ Oil on board, 2⅞" × 3¾" (7cm × 10cm) ~ Collection of the artist

Selecting Subjects for a Landscape

When painting small landcapes, it's impor- tant to select subject matter that is not too detailed. In still lifes you can arrange and select objects to fit a small format. Painting landscapes is a matter of selecting and simplifying the enormity of the information that is in front of you. The more complex the landscape, the more you have to simplify. Squinting or taking off your glasses will work to eliminate details.

Learning to mass forms is important. Learn to see trees as one shape instead of painting each individual leaf. A lawn is not made up of individual blades of grass, but seen as a plane in space. The challenge is to render trees and buildings recognizable without using too much detail. Trees in the background need to have less detail than trees in the foreground. They need enough leaves to look like trees, but not too many, or they won't stay in the background. Each area has to have its own identity.

Form Over Detail
Squint or take off your glasses to see the basic form of a shape. When you're painting in such a small format, creating recognizable forms is more important than capturing all the detail.

"Composing" a Landscape
If you're painting en plein air, start your com- position at least 25 feet (8 meters) in front of you. Look for interestingly shaped trees and contrast them with more traditionally shaped trees to create interest.

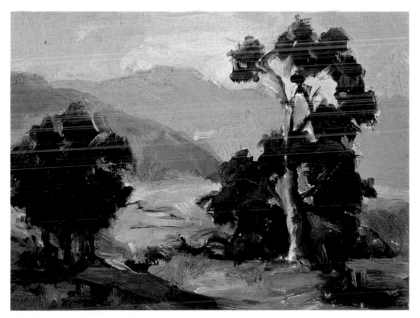

HOMAGE TO WATCHEL ~ Oil on board, 2⅞" x 3¾" ~ (7cm x 10cm) · Collection of the artist

Creating Depth With Placement

The correct placement of objects can create depth in your paintings as well as fully engage the small space of your compositions. When working on such a small scale, every inch counts.

You can compose a fuller, more abundant picture when you overlap objects. In a small painting format, the overlapping of planes and objects is the most useful tool for creating perspective and dimension. Avoid objects that just touch each other. This causes much confusion in compositions. When one object overlaps another there is no doubt which object is in front and which is behind.

Also, remember to keep things in proportion. As shapes move to the background they get smaller. Objects, planes and shapes will diminish in size as they recede into the distance. Practice this by drawing the same shape at several different distances and making it continually smaller as it approaches the horizon.

The Advantage of Overlapping
The sketches on the right demonstrate how overlapping lends instant depth to a picture, as opposed to the sketches on the left, where the subjects touch and look flat.

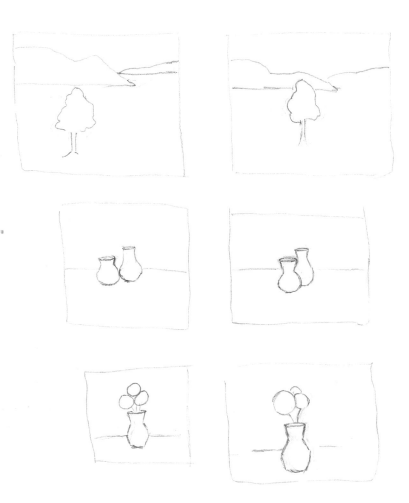

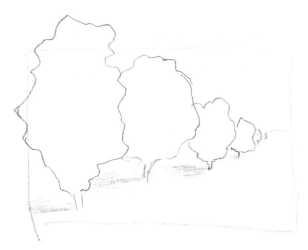

Perspective in Landscapes
These trees get smaller as they move towards the horizon line, creating realistic perspective.

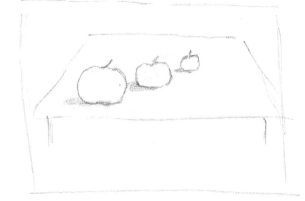

Perspective in Still Lifes
These apples get smaller as they move towards the background, making the table look three-dimensional.

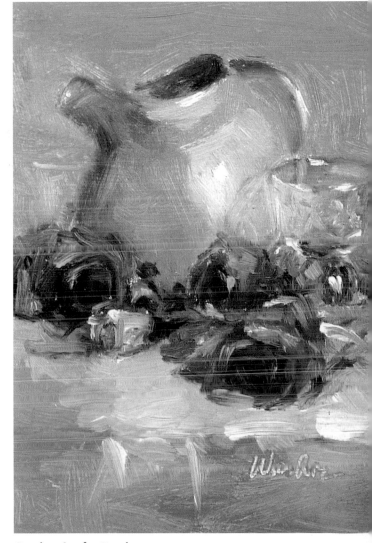

Overlapping for Depth
The roses overlapping this pitcher make the table appear very deep.

PITCHER AND JANET'S ROSES ~ Oil on board,
3¾" × 2⅞"-(10cm × 8cm) ~ Collection of the artist

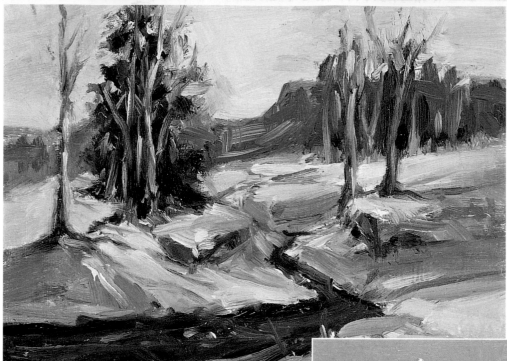

Keep Your Subjects in Proportion

The tree in the foreground extends beyond the edge of the composition, making it seem nearer to the viewer than the other trees. The trees in the middle ground and background are smaller and less detailed, making them appear farther away.

WINTERLUDE ~ Oil on board, 3¾" × 2⅞"-(10cm × 7cm) ~ Collection of the artist

Realistic Roses

These roses either overlap each other or appear by themselves. This lends them a sense of realism—it's how roses actually look in a vase.

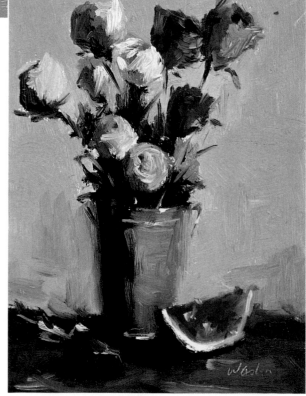

STILL LIFE WITH WATERMELON ~ Oil on board, 3¾" × 2⅞"-(10cm × 7cm) ~ Private collection

Using Negative Space

The Chinese principle of yin and yang describes the coexistence of opposites. In the same way that we referred to the yin and yang theory in our color palette, we can use it in building a composition. A composition is made up of fullness and emptiness. The fullness (subjects) is the positive space and the emptiness is the negative space. The positive space is the area occupied by an object. The negative space is the unoccupied area.

The ancient tao symbol of yin and yang shows us that the negative space is equally as important as the positive space. I remember my teacher HongNian Zhang explaining this principle by saying, "You can't have the front of your hand without having the back of your hand. One supports the other." Do not underestimate the importance of negative space. Use it to support and enhance the subject matter, define the shape of the object and bring variation to the composition.

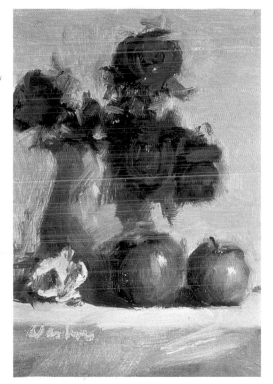

Negative Space in Still Lifes
The negative space in this still life is in the wall and the table, which brings out the red roses and helps define the shape of the vase.

Simplify the Spaces
When shown in black and white, it's easy to see how the negative space (the white) is as much a factor in a composition as the positive space (the black).

✦ WINTER APPLES ~ Oil on board, 3⅜" × 2½"
(9cm × 6cm) ~Collection of Aleece Strachen

Defining the Land

The negative space of the sky and river helps bring the trees and ground forward, establishing the three-dimensional illusion of the piece.

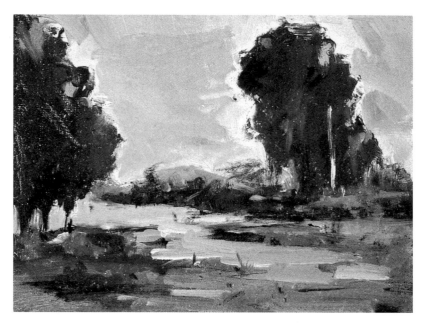

Negative Space in Landscapes

The sky in a landscape is often negative space that can be used to open up the composition and emphasize the subjects.

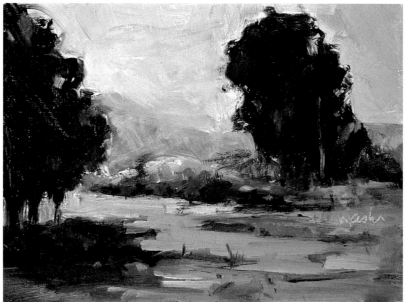

AUTUMN LIGHT ~ Oil on board, 2⅞" × 3¾" (7cm × 10cm) ~ Collection of the artist

Creating a Center of Interest

The center of interest or the focal point is where you want the viewer to look first. It is the place in the composition that has the greatest contrast, the highest color intensity and the sharpest edges. This can be emphasized by making the rest of the painting have less contrast, less color intensity and blurrier edges.

Each painting should have just one focal point. The general rule is to not put the center of interest in the center of the painting. It should be a different distance from each edge of the painting. Also, in order to maintain balance in the composition, for each object you place you need to compensate on the other side of the painting by placing other objects. One side of a painting should not be more cluttered than the other.

Do not divide the composition in half or in equal thirds. The reason is that you will end up with two (or three) different paintings. The best way to get an interesting composition is to have unequal divisions. Think of the canvas as a tic-tac-toe board: The places where the lines intersect are ideal points to place the center of interest.

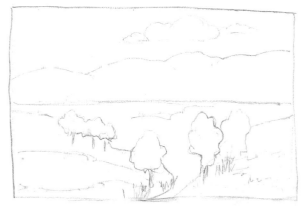

Don't Divide Your Composition
This composition is too static—it's divided into equal halves, denoting no clear center of interest and creating no movement.

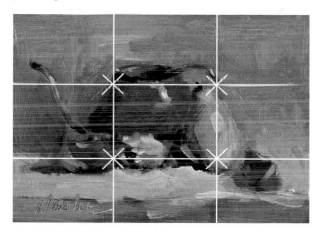

Placing Your Center of Interest
Dividing your canvas as though it were a tic-tac-toe board can help you decide the best place to put your center of interest—where the lines intersect is ideal.

❊ RED/GREEN COMPOSITION ~ Oil on board, 2½" × 3⅜" (6cm × 9cm) ~ Collection of the artist

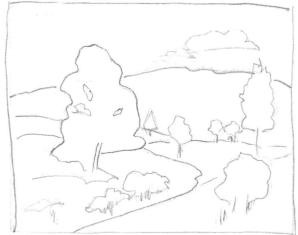

Creating Movement
In this sketch, the tree on the left is the clear focal point and the sky, tree and paths help emphasize it and move the viewers eye through the drawing.

Establishing Depth With Value, Intensity and Temperature

Value, intensity and temperature can be used to create the illusion of depth and space. You can use varying colors to mark every change of surface, light or reflection. Where there is a plane change, there should be a color change. Each side of an object receives a different amount of light, so the nuances of color can help define where the edges are and lend dimension to your shapes.

To illustrate the idea that each plane on an object is a different color, peel a pear, creating many different planes. Place it in your shadow box and shine a bright light on it at a 45-degree angle. Each part of the pear that was sliced off is now a different plane receiving a different amount of light, and so the pear appears to contain many colors.

Warm colors appear to advance and cool colors recede (temperature). Brighter colors should be used in the foreground, and should dull as they recede (intensity). Colors lighten as they recede, so place your darker colors in the foreground (value).

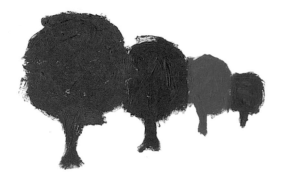

Temperature
Use warm colors to make your focal point advance and cool colors to make objects recede into the background.

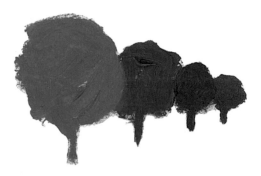

Intensity
Use brighter colors in the foreground to make those objects more prominent.

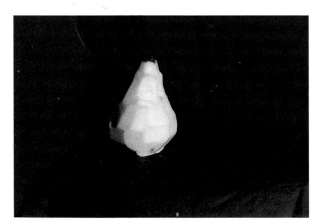

Changing Planes, Changing Colors
Peeling a pear and putting it under strong lighting is a good way to see how each plane of an object is a different color.

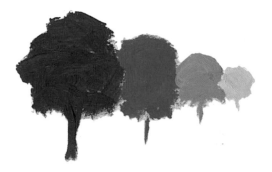

Value
As you move from the background to the foreground, your colors should become darker.

The sky color is dragged into the mountain, making the value lighter and helping it recede into the background.

This foreground red is almost directly from the tube (very intense) and is the warmest color in the composition.

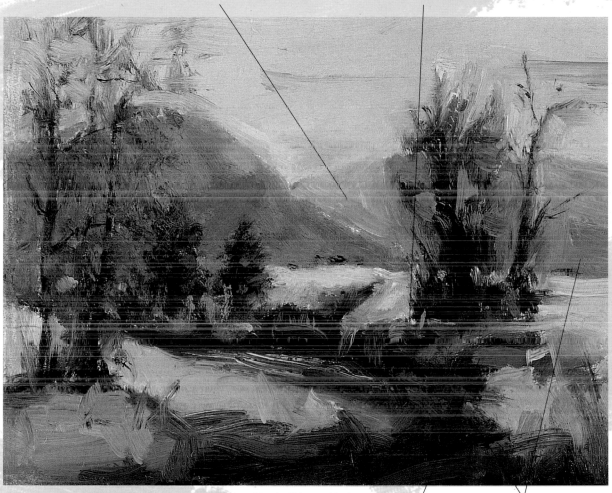

LANDSCAPE #0274 ~ Oil on board, 2⅞" × 3¾" (7cm × 10cm) ~ Private collection

This foreground green is more intense than this background green.

This blue is dark compared to the background blue.

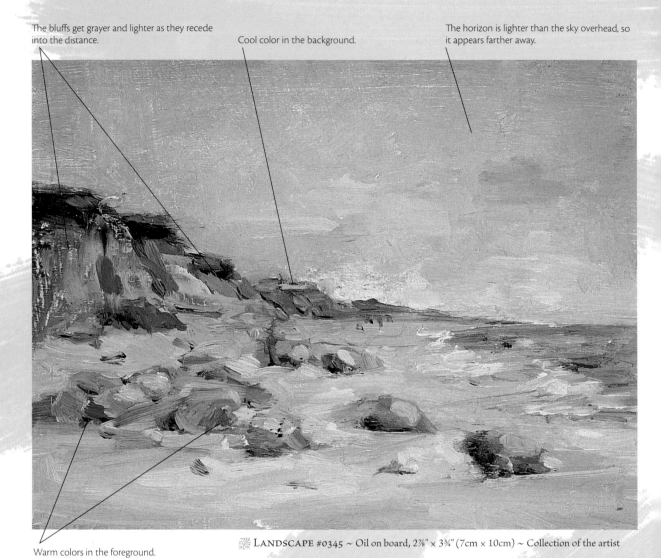

The bluffs get grayer and lighter as they recede into the distance.

Cool color in the background.

The horizon is lighter than the sky overhead, so it appears farther away.

Warm colors in the foreground.

LANDSCAPE #0345 ~ Oil on board, 2⅞" × 3¾" (7cm × 10cm) ~ Collection of the artist

Cool blue is dragged across the background, pushing the area back.

The clouds are light in value and low in intensity.

The mountains are light in value and cool in temperature, compared to the warm foreground.

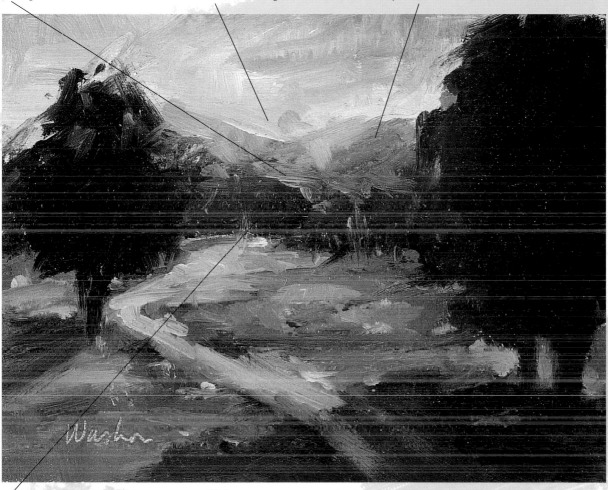

This dark red is used liberally in the foreground, and in only tiny amounts in the middle ground.

LANDSCAPE #0505 ~ Oil on board, 2⅞" × 3¾" (7cm × 10cm) ~ Collection of the artist

Using the Principles of Perspective

*E*ven in small paintings, it's crucial to adhere to the principals of perspective and dimension. Persepective comes from the Latin meaning "to see through," and is the art of drawing objects with a sense of depth and distance. It is the key to creating landscape paintings that look as though you could walk into them, and still lifes that look as if you could touch the objects. Use perspective, depth, object placement, value, intensity and temperature to make your paintings leap off the page.

Since I've started "boxing" shapes, especially flowers, my paintings have had so much more depth. "Boxing" refers to building a form on a cube. Boxes have vanishing points that create depth and obvious planes that show the differences in the light's effects, so they can be great models for anything you're trying to draw realistically.

Boxing Match

Building your forms around a cube shape can help you see where the planes and vanishing points are that can create depth in your work.

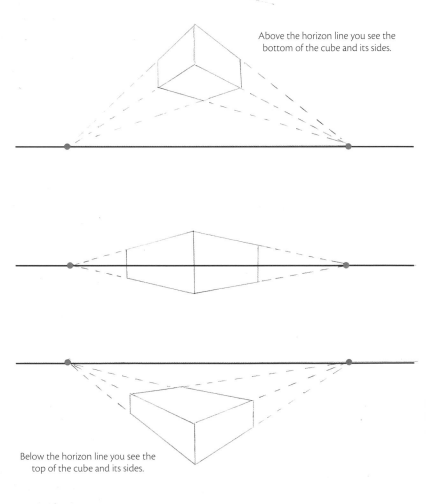

Above the horizon line you see the bottom of the cube and its sides.

At the horizon line you don't see the top or bottom of the cube, just the sides.

Below the horizon line you see the top of the cube and its sides.

Vanishing point ●

Horizon line ——

Linear Perspective

Linear perspective is a result of vanishing points and angles. To create linear perspective, you need to assign an eye level to the composition. Eye level is the height at which your eye observes an object. It's synonymous with horizon: where receding lines meet. Converging (parallel) lines, eye level and vanishing points are what create linear perspective. A vanishing point is an imaginary point on the horizon where converging lines meet.

The horizon not only refers to landscapes, but to still life paintings as well. Objects need to be drawn in perspective—they should get smaller and closer together as they recede in space and converge at an imaginary vanishing point.

One-point perspective: There is only one vanishing point on the horizon line.

Two-point perspective: There are two vanishing points on the horizon line.

Three-point perspective: There are two vanishing points on the horizon line and one point that indicates either depth or height.

Two-point perspective is the most common in small paintings. Use one-point perspective when standing in the middle of a railroad track, city street or river. Three-point perspective is needed only when dealing with extreme heights or depths.

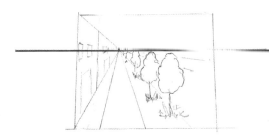

One-Point Perspective
Use one-point perspective when you are looking straight down a road, set of tracks or anything else that disappears at one point.

Two-Point Perspective
This is the most common perspective you will find in small paintings—use it when you're viewing the center of a building and are able to see both sides. Each side has a vanishing point.

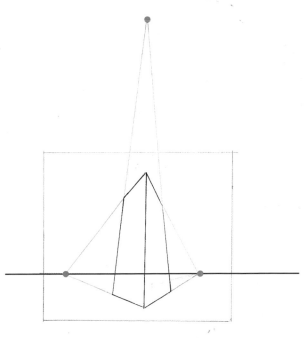

Three-Point Perspective
Use three-point perspective when depicting very tall buildings. The third vanishing point is in front of the viewer, at a 90 degree angle to the horizon line. It can be out of the picture frame.

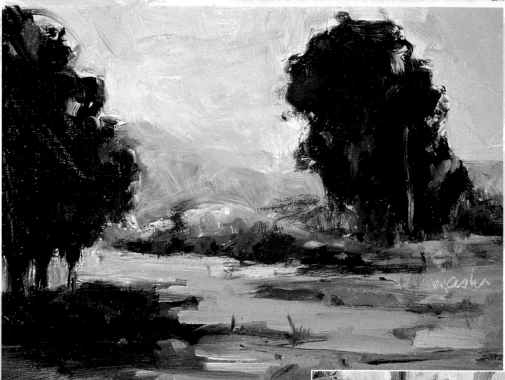

Painting Two-Point Perspective

The majority of landscapes will be done with two-point perspective. Objects in this picture get smaller and less defined the farther they move toward the background, and the most distant objects are indistinct.

❧ LANDSCAPE INSIDE ~ Oil on board, 2⅞" × 3¾" (7cm × 10cm)

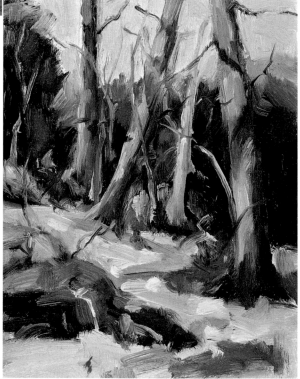

Painting Three-Point Perspective

In three-point perspective, the third point has to be either very high or very low. In *Woodland Interior*, there are two points on the horizon and the third is in the sky (off the page). The tree trunks are converging to this point.

❧ WOODLAND INTERIOR ~ Oil on board, 3¾" × 2⅞" (10cm × 7cm)

Atmospheric Perspective

Atmospheric perspective (sometimes called "aerial perspective") is one of the foremost tools used to create depth in landscape painting. It requires an understanding of how the atmosphere or air affects a painter's color choices.

The science behind aerial perspective is that there are veils of atmosphere created by moisture, dust, insects and pollutants in the air. The greater the distance between you and your subject, the more veils there are.

This becomes translated in painterly terms by the use of color. Cool colors recede. Warm colors advance. All colors get bluer as they recede. Dark colors get lighter and light colors get darker. The colors become very close in value. The edges get softer and softer as the shapes recede in space. Paint objects in the background with less clarity.

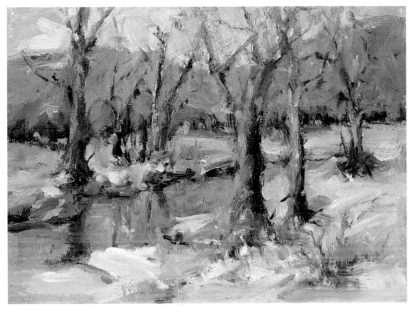

Temperature and Perspective

Using color temperature is one of the most effective ways of establishing atmospheric perspective. Here, the brightest and warmest trees are used in the foreground. The mountains are cool, which recedes, and their purple tone is very gray. Notice also how the white of the snow gets cooler and darker as it moves toward the background.

✤ LANDSCAPE #0276 ~ Oil on board, 2⅞" x 3¾" (7cm x 10cm)

Creating Atmospheric Perspective

Creating realistic atmospheric perspective in your landscapes—painting the layers of air between the viewer and the subject—is best achieved by the use of color.

The reds in the foreground are warm colors, which advance.

The clouds and mountains have soft edges, which help push them into the background.

This background purple is a cool, receding color.

Hard edges create distinct shapes for the foreground.

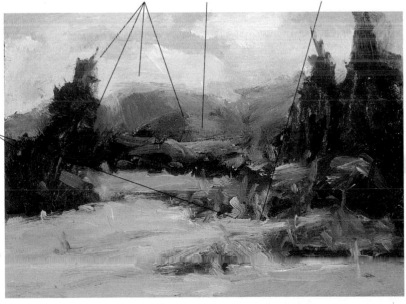

✤ JANUARY SNOW ~ Oil on board, 2⅞" x 3¾" (7cm x 10cm) ~ Collection of the artist

Creating Three Dimensions

Dimension is an art of illusion. As painters, we are translating a three-dimensional world onto a two-dimensional surface. There are several tricks you can use to make this possible.

To strengthen the illusion of height, width and depth on a two-dimensional surface, the use of chiaroscuro was employed during the Renaissance by painters such as Leonard da Vinci, Tintoretto and Raphael. Chiaroscuro comes from the Italian *chiaro* (light) and *oscuro* (dark). It describes the use of a range of values created with shading and highlights to create the illusion of form and weight.

Being able to render an object three-dimensionally will heighten the illusion of depth. There need to be five tones or values to create volume. There is the highlight, the light side, the shade side, the reflection and the cast shadow. Remember to use only one light source on your set-up.

If your light source is cool, the shadows will be warm. If the light source is warm, the shadows will be cool. The highlight will be a complement (in light value) to the light side color. Use a neutral color where the light side meets the shaded side. This is called the turning edge. The reflected light is lighter than the shadow color. The darkest color is located underneath the object. This is where the object meets the surface it is resting on.

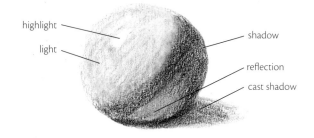

highlight — light — shadow — reflection — cast shadow

Five Tones on a Sphere
Use these five tones on your subjects to create realistic dimension and volume. This sphere is drawn with the light source coming from above left.

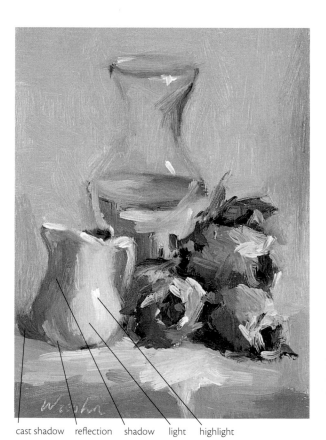

cast shadow reflection shadow light highlight

Five Tones in Color
Value is harder to see in color, but so necessary in establishing three dimensions.

Seeing Geometric Forms

*I*f you're having trouble deciding on the value of an object, go back to the basics: Look for the geometric form. It is either a sphere, cone, cube, pyramid or cylinder. Painting objects this way will give them more weight and mass. Mountains are a group of pyramids, trees are cylinders with spheres on top. Clouds are spheres—they're very light but won't be believable unless they are painted as if they had some volume. Rocks are different-sized cubes. Some have half spheres on top.

Your still life objects need to be regarded in the same way. Bowls and cups are spheres with the tops cut off. Flowers can be spheres, inverted cones, cylinders or combinations of forms.

Creating a Set Up
To practice seeing geometric forms, create a set up of some of your favorite still life subjects.

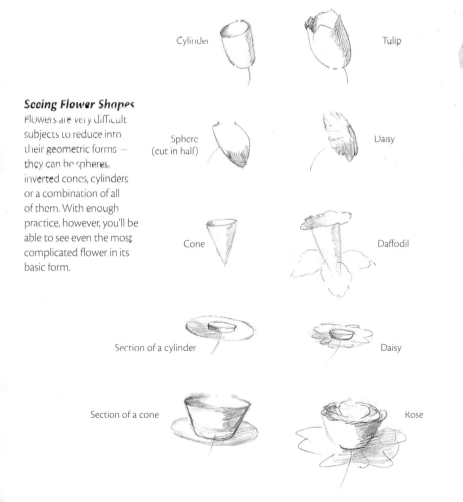

Seeing Flower Shapes
Flowers are very difficult subjects to reduce into their geometric forms — they can be spheres, inverted cones, cylinders or a combination of all of them. With enough practice, however, you'll be able to see even the most complicated flower in its basic form.

Cylinder

Tulip

Sphere
(cut in half)

Daisy

Cone

Daffodil

Section of a cylinder

Daisy

Section of a cone

Rose

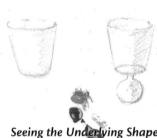

Seeing the Underlying Shapes
The pitcher and cup can be reduced to cylinders and a cone, which makes it easier to decide where to place your values.

Scaling Down Your Compositions

One of the hardest things to get used to when painting small is scaling down your composition to fit within a sight size of 2½" × 3½" (6cm × 9cm). Obviously, whatever reference you're painting from is probably not that small, and it can seem like an overwhelming challenge to scale things down. When I was first struggling with this concept, I came across a postcard from a two-person show I was in that featured an image of my 11" × 14" (28cm × 36cm) painting at about 3" × 4" (8cm × 10cm). Seeing this visual was a great help to me—it was a realization that I don't have to sacrifice anything to paint on a small scale.

While setting up your still life or contemplating a landscape, you can use your hands or two L-shaped pieces of cardboard (fits together to form a frame) to block in a composition at the size you want it. This way, you can see exactly how much you can comfortably fit within your format at the very beginning of the process.

If your resulting drawing is still too large for this smaller format, you can use a photocopy machine or computer to scale it down. If you usually paint at 16" × 20" (41cm × 51cm), try going from an 8" × 10" (20cm × 25cm) to a 5" × 7" (13cm × 18cm) and on down until you reach the small format that you'd like to paint.

After I spent a couple of months painting at the 2½" × 3½" (6cm × 9cm) format, it began to feel the same as an 11" × 14" (28cm × 36cm) or a 16" × 20" (41cm × 51cm). It's a little hard to explain, but the paintings feel so large and complete to me it's as if I can walk around in them.

Photo by Paul Saltzman

Create a Small Composition
You can use your hands or two L-shaped pieces of cardboard to help you see how much you can fit within a small format.

CREATING SMALL DRAWINGS
Shrinking Your References

*O*ne of the best things you can do to render what you see as life-sized into a small format is to draw the composition as a single unit, not as individual items.

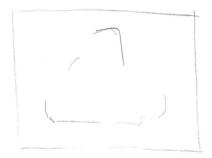

1 DRAW THE BASIC OUTLINE
Start by blocking in the outermost edges of the objects—but as just one shape, not individual shapes.

2 FILL IN THE OUTLINE
Draw the edges of the shape made by the objects, and add the table top.

3 FINISH THE SKETCH
Now you can look at each object individually and add in each distinct shape.

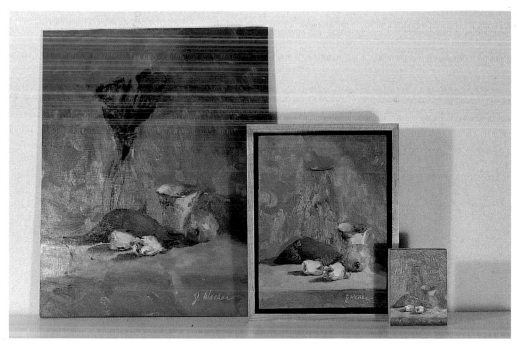

Finished Painting at Three Different Sizes
By looking at your still life set-ups as one big shape instead of a collection of objects, you can draw accurate representations at any size.

Drawing Techniques

Good paintings, especially those on small canvases that have to pack a lot onto a little, begin with good drawings. There are several drawing techniques I use to help capture my subjects realistically.

Drawing Through

When drawing a scene, still life or a landscape, you should draw the parts that you can't see as though you can see the hidden edges right through the other objects. This helps you capture the total form of your subject and helps you draw it more realistically.

Using A Center Line

Every object has two identical sides—each side should be the mirror image of the other. When you're drawing an individual item, try placing a line down the middle of it to make sure the sides are identical.

Measuring

If you measure one object in a composition and use its size for reference when drawing the other objects, it will help everything be to scale. Each object will be the right size in relation to the other items.

Capturing All the Edges
Drawing all the things you can't see but know are there, like the back rim of this bowl, will help you get the right proportions even on a small canvas.

Drawing Through The Foreground
Draw the edges obscured by other objects to capture the scene you're going to paint more realistically .

Drawing Identical Sides
Every symmetrical object has two sides that are mirror images of each other. Drawing a line down the center to check your accuracy can result in better, more realistic paintings.

How to Measure
Pick an object in the set-up for reference. Grab a pencil, fully extend your arm out in front of you and close one eye. Place your thumb on the pencil where the bottom of your reference appears.

Using the Measurement
Use the measurement you took on the pencil to find the heights and widths of other items in the composition. For instance, the bottom of the pitcher is as wide as the flower is high.

Massing Shapes

When you're creating a drawing that will become a painting, it's best not to draw each item individually: Draw the shape that the objects create together. It helps to think of a mass instead of a collection of objects so that you can model the form as a whole unit. Once that's established, you can break it up with the details as much or as little as you would like.

This is especially helpful when drawing a bunch of grapes or cluster of trees. It's a simplification technique that's good for all painters, but especially so for those who create small paintings. Massing keeps you from wanting to paint every leaf or petal at the start of your painting instead of at the end, when you should. Paint volume, not lines. Think of volume as a geometric form.

Drawing the Planes

Instead of drawing the curves you see in objects, try rendering them with straight lines in order to make the planes more obvious. A plane change means a color change, and if you can see these changes easily in your drawing, you can paint each plane differently and make the object more three-dimensional.

Correct

Incorrect

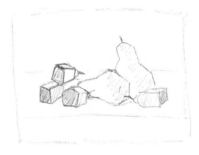

Using Straight Lines

These pears and flowers were drawn using straight lines, so the plane changes are easily seen and I'll be able to tell when to switch colors.

Drawing the Shapes, Not the Subjects

As with these flowers and grapes, depicting them as a few separate shapes rather than a collection of details will help you more accurately capture your subjects in paint.

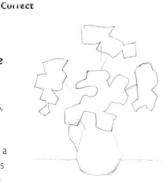

Correct

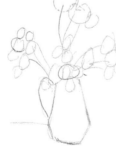

Incorrect

Combining Techniques

In this drawing, the grapes are massed and the grapefruit and flower bud were drawn using planes.

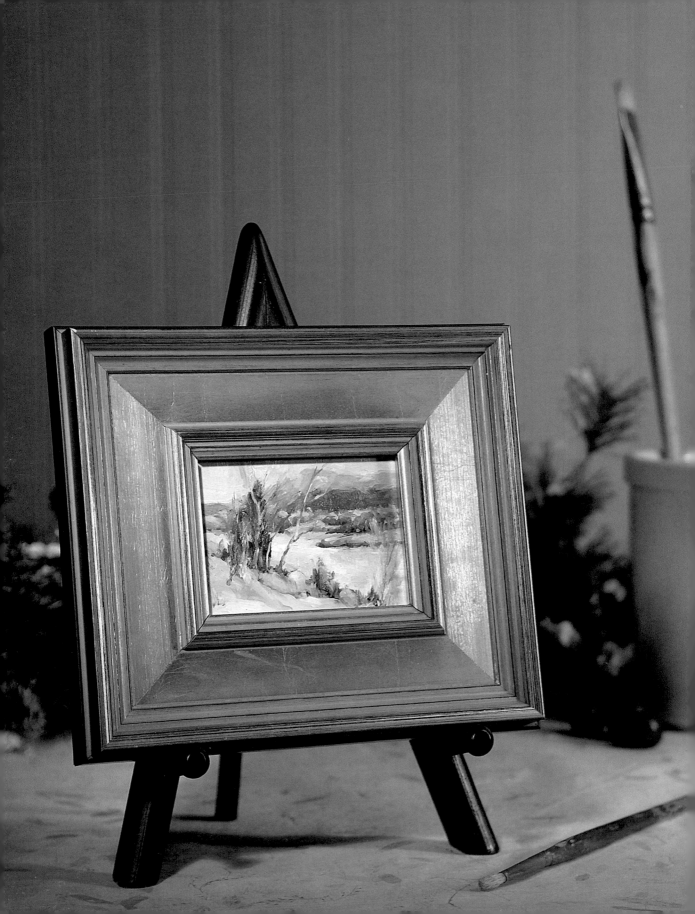

four
TECHNIQUES
for TINY OILS

I GOT INTO THE HABIT OF WORKING ON MORE THAN ONE PAINTING AT a time when I started creating smaller paintings. It seemed like there was a lot of paint mixed, and using another board was just a matter of pennies. I feel freer having two or more paintings going at once—instead of just working on one that feels overly precious, I can experiment with different colors or compositions without worrying so much that I'm ruining it. At the end of the painting session all the boards look pretty similar; then I change what didn't work to what did work on all the paintings.

I've always thought of painting small as doing a regular size painting (say, 16" × 20" [41cm × 51cm]) in a small format. Maybe that's from living and working in a New York City studio apartment. You have to figure out how to get all of what you need into a small space. That's how I think when I'm doing a small painting. I want it to have everything a large painting has. I don't want it to be a study of a single piece of fruit. I want it to have movement and space, just like a large mural has. I think about painting planes and forms and the basic geometric shapes. I look at how the light hits the forms. I change the color when the plane changes.

You will be surprised how few details you need to make a painting look "real." Just because you are painting small does not mean you need to focus on details. Small paintings are no different from large paintings. You have to paint the dog before you paint the fleas. You have to get the foundation down before you do the decorations. No one would (or could) hang a picture on a wall before the house has been built. I find that once I've started focusing on my 3" × 4" (8cm × 10cm) board there is a very large work space. Somehow it grows and there is enough room to place everything I need to make a painting that includes all the principles of a full-scale work.

DEMONSTRATION
Blocking In the Basic Shapes

*A*fter establishing the composition, the first thing you should do with the paint is block in the basic shapes. If you cover the largest components of the piece with paint, you can choose the other colors based on these more dominant hues. Your color choices for the block-in should be well thought out, not made hastily. Every stage of the painting process should be well-designed. Look for the biggest shapes in the different planes of the composition and block in both their light and dark sides. Remember to squint to simplify the shapes and make the values easier to see!

Materials List

OIL PAINTS

Winsor Green (Winsor & Newton), Permanent Rose (Winsor & Newton), White (Permalba), Chrome Green (Rodney Georgian), Winsor Red Deep (Winsor & Newton), Sap Green (Winsor & Newton), Cadmium Orange (Winsor & Newton), Permanent Green Light (Winsor & Newton), Purple Madder (Winsor & Newton), Permanent Green Deep (Winsor & Newton), Winsor Green (Winsor & Newton), Raw Umber (Winsor & Newton), Indian Red (Winsor & Newton)

BOARD OR CANVAS

3″× 4″ (8cm × 10cm)

BRUSHES

no. 00 round, no. 0 round, no. 1 filbert, no. 2 filbert

OTHER MATERIALS

pencil, carbon paper, tracing paper, palette knife, paper towels

1 DRAW THE SCENE AND PLACE THE VALUES

Create your drawing and roughly block in the values you want in the finished piece.

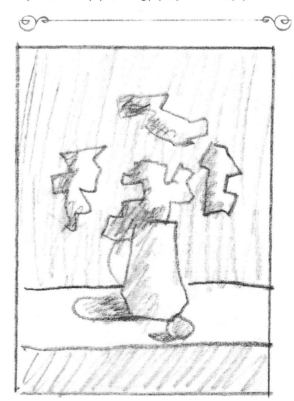

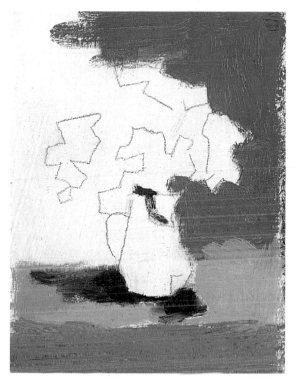

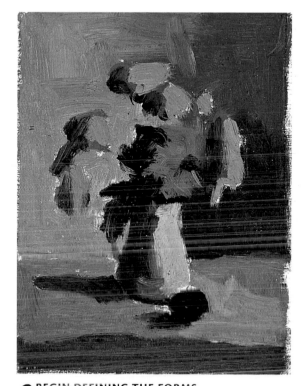

2 BLOCK IN THE BACKGROUND AND TABLETOP

Transfer the value sketch (only the outline is necessary; you can use the sketch for reference) to your board or canvas using carbon paper. Use one color for each variation of light and shadow, i.e., a different color for every plane of the major areas, the background and tabletop. Lean to the darker side of the values: It's easier to make a dark color light than a light color dark. Also, since the light is coming from the right, the cast shadows should appear on the left.

Paint the background with a mixture of Winsor Green, Permanent Rose and White with a no. 2 filbert. The tabletop is a mixture of Chrome Green, Winsor Red Deep and Sap Green applied with a clean no. 2 filbert. Use a mixture of Cadmium Orange and Permanent Green Light and a no. 2 filbert for the front of the table, and add the dark purple accents with a no. 1 filbert and a mixture of Purple Madder and Permanent Green Deep.

3 BEGIN DEFINING THE FORMS

When the board has been covered with the correct values and tones for each major form, the blocking is finished and you can begin defining the forms. Paint the green reflection on the front of the vase with a no. 1 filbert using a mixture of Permanent Rose, Winsor Green and White. Add Raw Umber to the mixture and paint the left side of the background. Create the dark green leaves with Purple Madder, Permanent Green Deep and Raw Umber using a no. 1 filbert. Paint the light green leaves with Sap Green, Chrome Green, Cadmium Orange and a no. 1 filbert.

Move to the right side of the composition and paint the light side of the vase Indian Red, White and Permanent Rose with a no. 1 filbert. Darken that mixture and paint the yellow side of the flowers. Paint the other side of the flowers using a no. 1 filbert with Winsor Green, Permanent Rose and White for the bluish tones and Purple Madder and Winsor Green for the purple.

Cool tones.

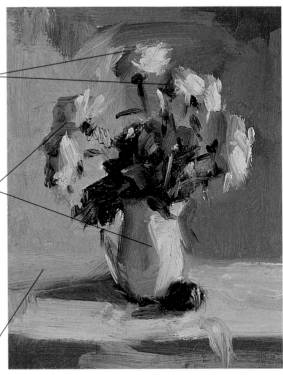

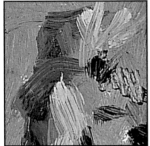

Warm tones.

Use cool tones to make the table-top recede.

4 FINISH THE PAINTING

To complete the painting and give it the proper depth, touch up the colors to distinguish the foreground from the background and really develop your subject. Warm colors advance and cool colors recede, so the outer edges of forms need cool colors and the centers need warm colors. Apply a warm mixture of Chrome Green, Cadmium Orange and White to the inside of the blossoms with a no. 1 filbert. Clean the brush and add a touch of Indian Red and Permanent Green Light to the middle of the flowers, then a cool mixture of Permanent Green Light and Permanent Green Deep to the outer edges.

Darken the stems of the flowers with Purple Madder and Permanent Green Deep using a no. 00 round. Switch to the no. 1 filbert and add highlights to the vase and flowers with a light mixture of Chrome Green, Cadmium Orange and White. Finally, clean the brush and darken the rose in front of the vase with Cadmium Orange and Purple Madder.

FLORAL COMPOSITION ~ Oil on board, 2⅞" × 3¾"
(7cm × 10cm) ~ Collection of the artist

DEMONSTRATION
Shaping a Three-Dimensional Image

We already know that value is the relative lightness or darkness of a color, but it is also directly related to how light shapes a three-dimensional image: more light results in a higher value, and less light produces a lower value.

There are five distinct colors created by light falling on an object that you need to capture in order to realistically render an object in three dimensions. This is also known as rounding a form.

These five tones are:
1. color for the side of the object in light
2. color for the side of the object in shadow
3. color for the light reflected from the ground into the shadow
4. color for the shadow cast by the subject
5. color for the highlight, where the most direct light hits

You can add additional transitional colors from one tone to the next that will help define your subject in space. Use a warm neutral color as a soft edge between the light and shadow. Use a cooler shadow color at the rear edge of the object to push it into the background. The trick for realism is to keep these colors related to the local color of the object. For instance, if you're painting a lemon, its color in the light could be a warm yellow. The shadow color could be very purple, but to make it look natural it has to have some of the lemon yellow.

Make sure the color of the light side of your object is dark enough to hold the highlight color. You don't want the two at the same value or you won't get the punch that adding a highlight should give an object.

The darkest color will be where the object sits on the surface. The shadow side and the cast shadow can be close in value. These will mostly depend on the color of the surface the object is resting on. The reflected light will be lighter than the cast shadow because the ground plane is reflecting light back into the object.

The highlight and cast shadow are a little tricky and are covered in more depth later in this chapter. The

cast shadow has some variations within itself—for instance, it will be darkest nearest the object. The highlight should not be just white. It should be the complement of the color used on the light side along with white.

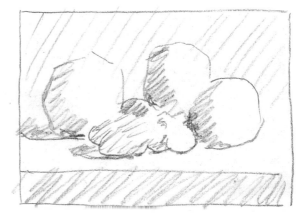

1 DRAW THE SCENE AND CREATE A VALUE SKETCH
When doing your initial drawing and value sketch, be sure to include the cast shadows in the composition.

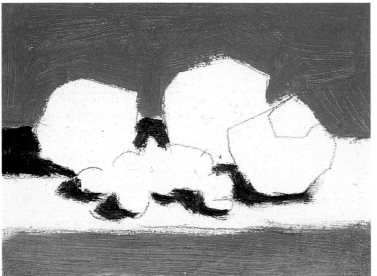

2 LAY IN INITIAL VALUES

After transferring your drawing to a board (do not transfer the value sketch—use it for reference), start by laying in the values and tones of the dominant areas of the painting, the background and the front of the table. Paint the background using a no. 2 filbert and a mixture of Winsor Green, Permanent Rose and White. For the front of the table, use the same brush with Sap Green and Cadmium Orange.

Add the cast shadows, keeping the darkest portion closest to the object casting the shadow. Use a no. 1 filbert with Purple Madder and Permanent Green Deep.

3 PAINT THE OBJECTS

Following your line drawing, paint the objects, making sure to use colors and values that reflect your initial lay-in. Paint the light and shadow side of each form with a no.1 filbert: the light side of the grapes is Chrome Green, Sap Green and a touch of Winsor Red Deep, and the dark side is Permanent Green Light and Winsor Red Deep. Paint the light side of the onions Chrome Green, Cadmium Orange and Sap Green, and the shadow side Permanent Green Deep and Pemanent Rose. Finish blocking in the composition by painting the tabletop Winsor Red Deep and Permanent Green Deep lightened with a lot of White.

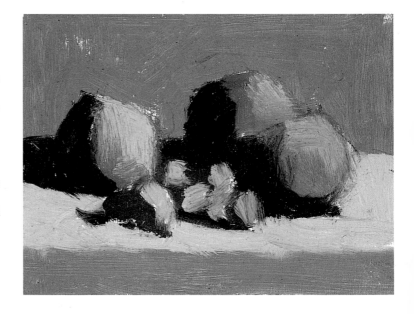

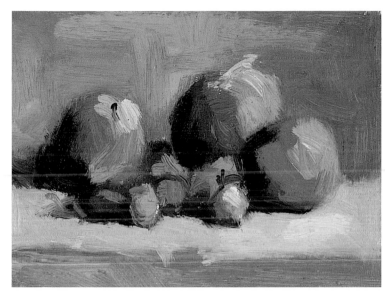

4 ADD THE REFLECTED TONES

The colors reflected from object to object are added only after the block-in and initial painting are complete, using a no. 1 filbert. Darken the bottoms of the onions with Cadmium Orange and Sap Green. Lighten this mixture with White, and add dabs to the shadow side of the grapes and onions. Lighten the right side of the tabletop with a touch of Chrome Green, Cadmium Orange and White.

5 PLACE FINISHING TOUCHES AND ADD HIGHLIGHTS

After the forms are completed, add any additional details and color notes. Place the highlights using a no. 00 round and the complementary color of the light side of the object mixed with a lot of white.

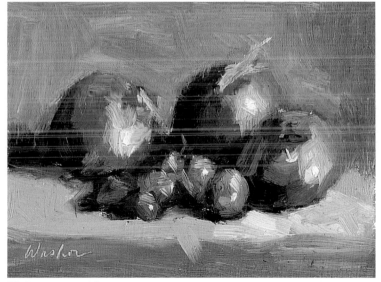

ONIONS AND GRAPES ~ Oil on board, 2⅞" × 3¾" (7cm × 10cm) ~ Private collection

Painting Cast Shadows

There are two different kinds of shadows. One is created by light hitting an object. The other, a cast shadow, is created because an object is blocking light from getting to the surface it's sitting on.

Shadows are important design elements. Use them to reinforce the shapes of the objects. A round pot will look even rounder when you paint the curve of the cast shadow. Cast shadows add to the realism of the picture and also act as a unifying design element. They can be used as a bit of breathing space. Instead of jamming one object next to another, you can let the cast shadow act as an element that separates them.

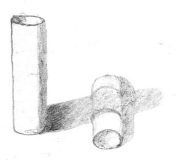

Overlapping Shadows

A shadow is darkest when closest to the object that's casting it; shadows that overlap are no darker than shadows that don't.

☙TIPS FOR CREATING☙ CAST SHADOWS

1. Remember to always use just one light source. If you use two, it will flatten the subject and make it two-dimensional. We live in a world with one sun, and that creates our definition of reality; therefore, to make an object look realistic to us, there needs to be only one light source. The shadow box will eliminate light coming in from other sources.

2. Allow space in the composition for the cast shadows. For example, set up a still life closer to the side where the light is coming from to make room for the cast shadow.

3. Shadows are denser the closer they are to the object. The intensity of the shadow decreases as it gets farther from the object. This is because more reflected light can invade the air.

4. Cast shadows will follow the form upon which they fall. If two shadows intersect, they will not be any darker than the shadow cast by one object.

5. The color of the cast shadow has two determining factors: the color of the form upon which it rests and the shadow color of the object. Remember that the shadow color always remains true to its local color. You can drag some of the surrounding color into the cast shadow to make it lighter as it moves away from its source. Do not paint hard edges for cast shadows, or they will read as objects.

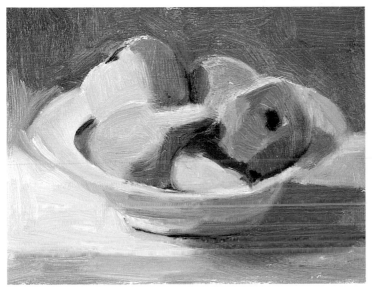

1 LAY IN THE VALUES

Complete the initial painting, laying in all the local colors and making sure to include the cast shadow shapes. Using a no. 2 filbert, paint the background with a reddish mixture of Winsor Red Deep, Permanent Green Light and White. Add more green to this mixture and paint the table. With a no. 1 filbert, paint the cast shadow of the bowl and the apples with the same mixture tinged with Cadmium Orange. Paint the bluish cast shadow on the bowl with Winsor Green, Permanent Rose and a touch of White.

2 DEFINE THE SHADOWS

The shadow side of the object demonstrates which direction the light is coming from, while the cast shadow defines the contours of the plane it's falling on as well as reinforcing the shape of the object casting the shadow. Soften the edges of the cast shadow so it doesn't look like an object, and keep the darkest tones close to the object that's casting the shadow. Paint the highlights with a no. 00 round and a light mixture of Chrome Green, Cadmium Orange and White.

Cast shadow from stem Darkest areas Cast shadow from stem

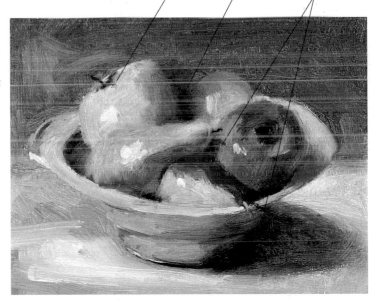

❋ APPLES AND PEAR ~ Oil on board, 2⅞" × 3¾" (7cm × 10cm)
~ Collection of the artist

Painting Highlights

Set up a still life so there's a distinct light falling on the objects that creates a well-defined shadow. Place your spotlight about twelve to eighteen inches from the set-up. The highlights will be a natural eye-catcher since they are so light (our eyes go to the light first). Don't create highlights that are off to one side or smack in the middle of the composition. They could well be your center of interest, so balance is important. Highlights generally fall on points that are concave (curving in) or convex (curving out).

Squint to make sure that the color you used for the light side of the object is dark enough to supply enough contrast for the highlight. If there is no "punch" (usually created by contrast) when you paint on the highlight, it's a clue that the base color is too light. If you are doing a painting that is all high in value, change the temperature of the highlight rather than the value. This is most likely to happen when painting snow.

Use the complement of the light color mixed with a lot of white. Due to the small size of the highlights, it's best to use a no. 0 or 00 brush. Apply the mixture with the thick opaque painting technique called *impasto*. When painting impasto, the brushstrokes should be readily apparent, helping lend texture and visibility to the area where they're used.

For example, if you're painting a lemon, start with white and add a tiny bit of purple (the complement of the lemon's yellow). Using the complement will make the highlight look even brighter. Avoid using pure white—it will make your painting look chalky.

❧PAINTING *IMPASTO*❧

Impasto is a painting technique in which the paint is applied very thickly. Usually, the brushstrokes are visible and lend to the texture of the piece. One of the things I love about oil paint is this property of being able to be applied thickly.

Shadows should be applied thinly. The lights should be applied more thickly, and the highlights the thickest. When the shadows are thin there is a greater feeling of depth in a painting, while thick paint adds a sensuous quality.

1 COMPLETE THE INITIAL PAINTING

Block in the colors of the background, tabletop, shadow and light sides, cast shadow and the darkest dark where the lemon rests on the table.

2 ADD THE HIGHLIGHTS

Paint the reflected colors and place a warm yellow in the center of the lemon, which will make this area appear to advance while the outer edges recede. Mix a little bit of purple into a lot of white, and, using a no. 00 round, push it onto the board and pull it away, leaving a "tail" of highlight. The soft edge of this tail will make the highlight appear as though it's sitting on the surface of the lemon.

LEMON ~ Oil on board, 2" × 2" (5cm × 5cm)

Using Different Brushstrokes

Essentially, your brushwork is your painting identity, your personality. It's easily the most fun part of any painting. It's where you get to loosen up and let it out. Just as everyone has a distinctive handwriting, everyone has a unique way of handling a brush with paint on it. After you've done the grunt work of mixing colors and blocking in the dominant areas, you get to apply the paint any way you want. You can twist, jab, swish, softly stroke or lift paint out with your brush. You can use the side of the brush or even your pinky finger.

It's generally best to use the largest brush you are comfortable using. This is so the area you are painting does not look dotted and broken up. Also, there should be a full layer of paint between you and the board. If the gesso was not evenly applied to the board, all the better. This will instantly add texture.

Don't hold your brush too close to the ferrule. (The ferrule is the part of the brush just above the bristles.) It's a brush, not a pencil. The further back you hold the brush, the more you will impart a painterly feel to the work. You should also remember to change your brush for different steps. Use broad strokes of a no. 2 or no. 1 brush to do your block-ins. Use smaller brushes to do thin, delicate strokes.

Load your brush heavily for lush, thick applications of paint in the light areas; use less paint for the darks. You can use your fingers or a palette knife to get different effects. In fact, you can use almost anything to paint with—experiment and see what suits your personality.

The paint on the brush can be applied so that it sits on top of the previous layer, or it can be applied so that it blends in with that layer. If there is too much paint on a previous layer and you find that the color is wrong, you can scrape the paint off with a palette knife. Some of the old layer will remain, but the paint applied over it will be the dominant tone. Also, your paintings will have a lush feeling if you go back for more paint after applying two strokes.

It's good to have both blended and sharp strokes for contrast. Use slow, deliberate strokes as well as fast, flourishy ones. Use short and long strokes, vertical and horizontal strokes. Use strokes that make definite shapes and some that make obscure shapes. It's easy to get carried away once you get started, however, so remember to discriminate.

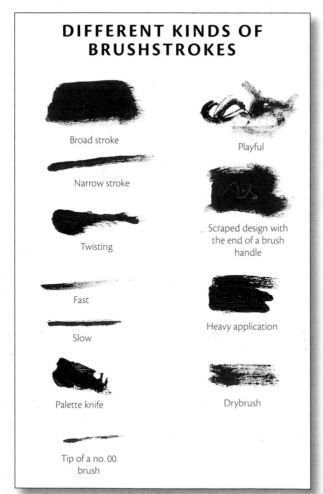

DIFFERENT KINDS OF BRUSHSTROKES

Broad stroke

Playful

Narrow stroke

Twisting

Scraped design with the end of a brush handle

Fast

Slow

Heavy application

Palette knife

Drybrush

Tip of a no. 00 brush

Creating Movement and Depth with Edges

Edges can be painted soft or hard; these are referred to, respectively, as lost and found edges. This is a technique that adds dimension to a painting. The hard edge will advance while the soft edge will recede. Edges are useful tools for taking the viewer's eyes around a composition. The hard edges will be the path that the eyes will follow. The soft edges will create depth by defining the object in space.

Remember to use sharp edges on your center of interest. Also, compare your edges to one another. If you want the edges of the center of interest to be the hardest, the rest will have to fall in line behind them. In the same way that you compare values and colors, compare edges.

The greater the difference in value between two areas of a painting, the harder the edge will be. Where two planes of the same value meet, there will be a soft edge. To create a soft edge, you can either blend one color into another while painting (working alla prima makes this easy) or mix a color that is a combination of the two edges.

Using Edges to Create Depth

In this painting, the tree on the left (the focal point) has hard, defined edges, while the tree on the right has soft, blurry edges. The viewer's eyes are attracted to the focal point first, and the tree on the right appears far in the distance and creates a sense of depth.

❀ LANDSCAPE #0506 ~ Oil on board, 3" × 3¾" (8cm × 10cm)

HARD EDGE

Use a different brush (or clean the same brush) and place two colors next to each other with no overlap.

SOFT EDGES

Overlap the darker color with the lighter color.

Place two colors next to each other, then use a clean brush to blur the separation.

Cross-hatch one color across the other with a clean brush.

Blend the cross-hatching lines with a vertical stroke.

Gradually feather the colors into one another.

Adding Exciting Textures

Our world is made up of different textures—smooth and rough surfaces, fuzzy and prickly objects, etc.—and as artists, being able to translate these textures into paint adds to the credibility of our work. The faithful rendition of color from life to canvas, the soft or hard edges of objects and the highlights will describe to your viewer the texture of your objects.

There are two ways I create surface texture on a painting. One is by using a brush loaded with paint, and the other is by using a palette knife to scrape away and smudge the paint. A thick buildup of paint on your canvas or board creates texture. Use this on objects in the foreground, since thick paint comes forward.

Using thin paint in the darks and thick in the lights aids in rendering objects three-dimensionally. The texture of your subject should be most obvious in the highlight. For instance, peaches and nectarines don't get highlights: Their softness and fuzziness mutes the light that hits them. On the other hand, shiny objects like apples need crisp, sharp highlights.

One of the great characteristics of oil paint is that it has body to it. It can be applied thinly or thickly. The initial block-in layer should be applied thinly. Build up the surface by adding color spots to round forms. The most thickly applied paint should be in the highlights and foreground. Use the most texture in the foreground. This is where you can let your brush fly.

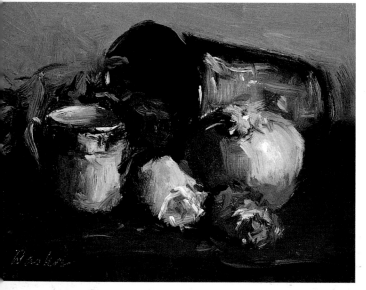

Comparing Highlights

The copper can gets a bright highlight, as does all shiny metal. Highlights should be compared to each other just as you would compare different color temperatures or values. The least bright highlight is on the fabric. Notice the buildup of paint on the fabric in the foreground.

Using Contrast and Complements to Make Colors Glow

The highlight on the gold case looks so bright because purple was used to paint the darker planes, which is the complement of the yellow in the case. Remember, placing complements next to each other will make them glow. The highlight on the onion looks bright because it is surrounded by a deep red of dark value and muted intensity.

🌸 GOLD VASE AND CUT ROSES ~ Oil on board, 2¾" × 3¾" (7cm × 10cm)

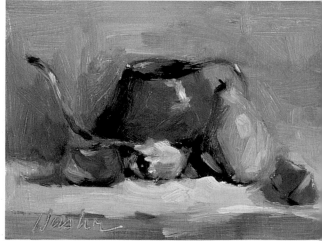

🌸 RED AND GREEN COMPOSITION ~ Oil on board, 2¾" × 3¾" (7cm × 10cm)

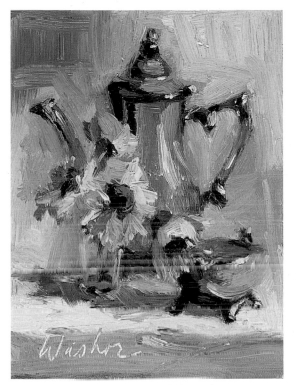

Using Highlights to Define Texture

There were a lot of reflections in the coffee pot and creamer, so I simplified what I saw by squinting my eyes. The brightest highlights and most intense colors in the coffeepot (oranges on the rims and handles) make it appear shiny. I liked the contrast of the shiny silver against the soft petals of the flowers.

MOM'S SILVER ~ Oil on board, 2¾" × 3¾" (7cm × 10cm)

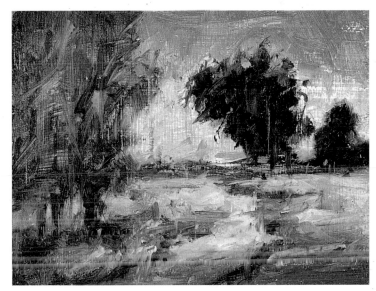

Adding Texture with a Palette Knife

The palette knife was used to scrape into the wet paint after the initial block-in was done. I intentionally left the scrape marks for texture. You can scrape into the board to draw objects or simply to create random textures. Scraping the entire board unifies the colors and the composition.

LANDSCAPE #0317 ~ Oil on board, 3" × 3¾" (8cm × 10cm)

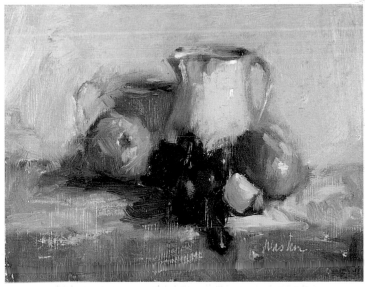

TWO PITCHERS AND TWO ONIONS ~ Oil on board, 3" × 3¾" (8cm × 10cm)

Scraping Off Excess Paint

The texture on the surface of the painting was created by using a palette knife to scrape off the excess paint after the block-in was done. I intentionally left some of the knife marks. I also didn't wipe the knife after each passage, so paint was deposited on other areas of the composition. The mysterious feeling is created by soft edges.

Painting in a Series

Painting in a series gives an artist time to really focus on capturing the essence of one place or scene, to warm up, explore, experiment. It's almost like giving yourself permission to be the most creative you can be. To me, it feels like an artistic exercise that gently pushes me to my limits and hopefully beyond. It's an in-depth investigation of a subject, and a heuristic, or self-teaching, approach to painting.

My favorite way to develop a painting is to use my own photograph of one of my favorite places, along with a picture from a magazine or book which has excited my color sense. The paintings here are done from a photograph of a favorite place I lived in upstate New York. Each painting was done using color inspiration from four different artists, and all were done in the course of a few hours. Of course, I don't want to minimize the struggle of creating a painting no matter what size it is, but I think I can safely say that painting small maximizes the chances of getting more done in less time.

❧ ALLA PRIMA PAINTING ❧

Alla prima is Latin for "at once," and basically denotes painting with no preliminary underpainting and finishing a piece in a single session. I generally think of someone painting outside in the fresh air, directly observing nature and doing quick oil sketches.

Usually I finish a piece in one day, but if I can't, I'll continue it the next day as long as the paint is still wet. Once the paint has dried, I discard a painting and start it over again. I would rather start over than fight with dried or almost-dried paint. Working with old paint takes the fun out of painting for me and it inevitably shows up—the painting looks uninspired. The spontaneity of being able to finish a painting in one session is very appealing to me.

In my small paintings, painting alla prima makes the paint behave exactly the way I want it to without having to use a medium. Since it takes less time to complete a smaller painting, the paint doesn't dry out and is completely malleable throughout the process, eliminating the need for paint-thinning mediums.

Capturing the Feeling
The colors of autumn were so extraordinarily beautiful in the Catskill Mountains that I was afraid to even attempt putting them on canvas. Doing this painting was a major breakthrough for me. I think it finally happened after looking at hundreds of paintings by other artists and trusting that I didn't have to get it exactly right, but could rely on sensory memory.

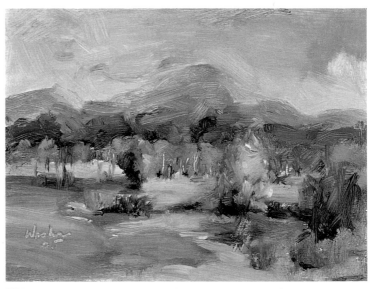

❧ LANDSCAPE # 0529 ~ Oil on board, 2⅞" × 3¾" (7cm × 10cm)

Reference Photo

This was taken near my old weekend house in Woodstock, New York. I like the deep feeling of space, the fields and the mountain range. It reminds me of many happy hours away from the city. Being familiar with the road in many times of the year made it easier to experiment with different color feelings.

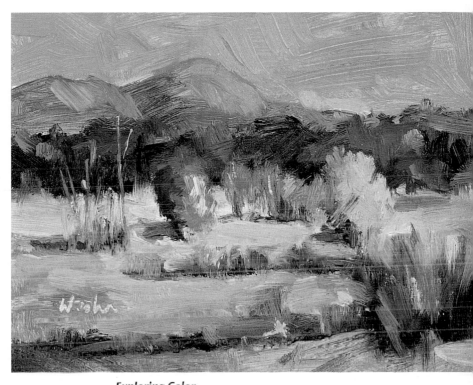

Exploring Color

I decided to do an interpretation with a bright blue sky and some orange to make a blue/orange statement. The ground plane is neutral, which contrasts with the more intense colors. This was the second rendition in the series and was painted in about two hours.

 LANDSCAPE #0524 ~ Oil on board, 2⅞" × 3¾" (7cm × 10cm)

Finding Inspiration

This was inspired by a painting I saw in a magazine that had a pink sky. I used the same reference photo, of course, but "grew" a tree on the left this time. This is probably the most successful of the group, and it's no wonder: it was done last. There's a lot to be said for working in a series. I'll probably go back to this same photo many more times with other images, feelings or moods to explore. That's one of the things I love about art; the inspiration and applications are endless. There's always room to improve.

LANDSCAPE #0539 ~ Oil on board, 2⅞" × 3¾" (7cm × 10cm) ~
Collection of Karen Shannon

Capturing Realistic Reflections

To paint objects with a reflective surface, such as this shiny coffee pot, use one color for the entire object: Don't break it down into the light and shadow side. Make sure you use a local color that's dark enough to contrast with the highlights and will help describe the form.

Obviously, the goal is to capture the reflections of the surrounding objects and colors. Try to keep the integrity of the reflective object while suggesting these reflections. Keep it as simple as possible. If a reflection is getting too complicated, just leave it out.

Make the object look three-dimensional by adding cool color notes to the edges and warm color notes in the center. It's more important to make the object look three-dimensional than it is to record every reflection. Remember to mix in a complementary color for the highlights. The highlight will be crisp and bright and should contrast greatly with the local color of the object.

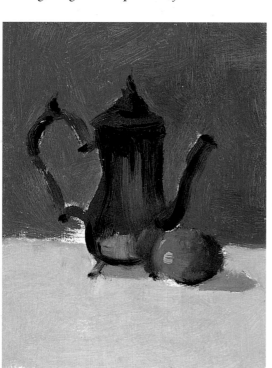

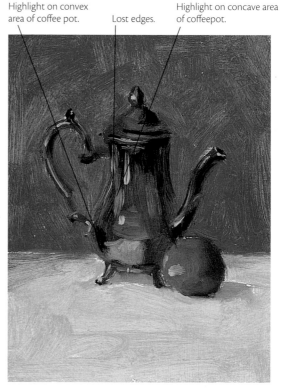

Highlight on convex area of coffee pot. Lost edges. Highlight on concave area of coffeepot.

1 COLOR THE DOMINANT SHAPES AND REFLECTIONS

Begin by blocking in the major shapes. Paint the coffee pot, background and orange. Paint the cast shadows blue with a hint of orange.

Add the reflection of the orange on the coffee pot. The reflection should be significantly duller than the orange itself. Also add the reflection of the background fabric. Keep the edges of the reflections soft—they should look like part of the surface, not a decoration on top of it.

2 MAKE IT THREE-DIMENSIONAL

Use both horizontal and vertical strokes to apply warm tones of Scarlet Lake mixed with White to the center of the coffee pot. Look for places to use soft, lost edges. Finally, place the highlights on the concave and convex points using the color of the tabletop.

Painting the Invisible

When painting a transparent object, instead of looking at it, look through it. Keep this in mind when you're setting up a still life featuring a transparent object, like this glass vase. The objects behind your subject need to be the right shapes, colors, etc.—you'll have to paint them all.

Place the transparent object in front of a plain object or overlap it with a small section of another object. This will ensure that its translucence is noticeable. Use one color for the background, then use a duller version of that color to paint the transparent object in front of it.

The highlight will appear on the opposite side of the light source. It passes through the side closest to the light source and ends on the opposite side. Look for opportunities to use a dark tone next to the highlight to make it look even brighter. Remember not to use pure white for the highlight, but to add a little bit of the complement of the local color to make it sparkle.

Drag the foreground color into the background and background color into the foreground to integrate the two and lend a painterly feel to the piece. Highlights. Lost edges.

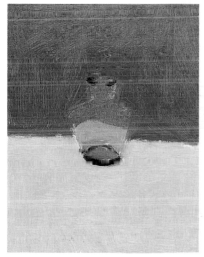

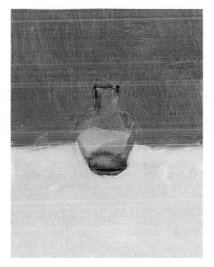

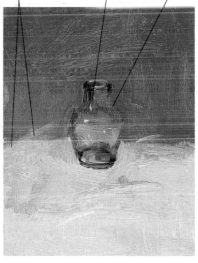

1 BLOCK IN THE DOMINANT SHAPES

The block-in can be tricky when painting transparent objects. As well as blocking in the colors of the dominant shapes, the background and tabletop, you also need to apply the color of the tabletop and background through the glass with a slightly duller version of those colors.

2 ADJUST THE COLORS

Most of the colors of a transparent object are at its edges. Squint to see where more color might be needed, but remember to keep it simple.

3 ADD HIGHLIGHTS AND DEPTH

Apply the most intense colors. Mix a highlight color of white with a touch of orange (blue's complement) and apply it to the vase. Darken the mixture with a little more orange, and place it just above where the tabletop meets the background to make the vase appear farther into the foreground. Look for spots to place lost edges, which will reinforce the transparency of the glass.

Finishing Up and Framing Your Work

The last technical details you need to worry about come after the painting is complete, and before you hang your work to enjoy.

Using Spray Varnish

Once you are finished with a painting and it's completely dry, use a spray varnish to bring the colors back to the way they looked when you applied them. In days past, you had to wait as long as six months for oil paint to dry thoroughly, but no more—there are products on the market, such as Kamar Varnish, that you can use as soon as the paint is dry to the touch. Just remember to use the spray outdoors or in a really well-ventilated area.

Framing Your Work

There are lots of good frames on the market, and I recommend trying many. Generally, I prefer using Franken Frames (www.frankenframes.com; [800] 322-5899) for most of my work. They have good quality frames at reasonable prices, and most importantly, they're willing to cut the frames down to accommodate my small painting size.

Franken Frames are good for beginners. Another source for frames is Geoffrey Rogers. His frames are more expensive, but the corners are finished as opposed to just being chopped and joined. You can reach Roger at (845) 254-5512—he's a really nice guy who's even been known to make house calls! In fact, we designed the frame in the illustration (bottom right) together. He's a great source for custom framing.

When ordering a frame, tell the framer the size of the canvas you're working on. If the canvas is 16" × 20" (41cm × 51cm), that's the size frame you order. When painting small every ⅛" (3mm) counts, especially when ordering a frame. Remember to ask for the frame's sight size! Ask for 2⅜" × 3¼" (6cm × 8cm) sight size and the boards will fit with just enough room.

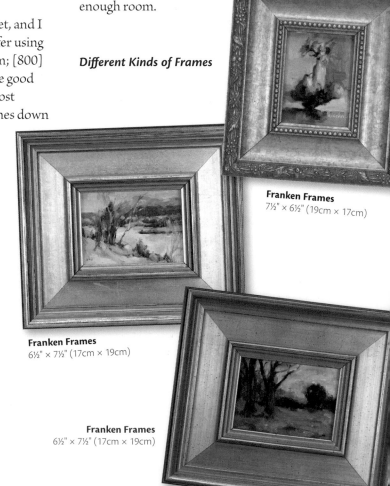

Different Kinds of Frames

Franken Frames
7½" × 6½" (19cm × 17cm)

Franken Frames
6½" × 7½" (17cm × 19cm)

Franken Frames
6½" × 7½" (17cm × 19cm)

Varnishing Your Work
Applying spray varnish to your finished, throughly dried paintings brings the colors back to their just-out-of-the-tube luster.

From Techniques to Practice

The first chapter dealt with the *what* of painting small: what paints, canvas and brushes to use. The second chapter covered *which*: which colors to use. The third was the *where* of placing subjects and colors. And this chapter, the fourth, was *how* to handle the paint and the brushes. The *why* can only be answered by you—why are you reading this book?

After much self-inquiry and soul searching, I quit my job and took a leap of faith, giving myself full time to painting. I had the good fortune to be enrolled in a painting class at the Woodstock School of Art with a generous and talented teacher.

In the midst of this painting frenzy, I developed a shoulder injury that prevented me from painting Shortly after this I met my spiritual meditation teacher, and soon thereafter started doing small paintings. With the help of grace, adversity turned into advantage.

Doing small paintings feels like the most natural thing in the world. Seeing has become to me as it was to the poet and mystic William Blake: "the world in a grain of sand.

Vincent van Gogh wrote to his brother Theo: "So I am always between two currents of thought, first the material difficulties, turning round and round to make a living; and second, the study of color. I am always in hope of making a discovery there, to express the love of two lovers by a wedding of two complementary colors, their mingling and their opposition, the mysterious vibrations of kindred tones. To express the thought of a brow by the radiance of a light tone against a somber background. To express hope by some star, the eagerness of a soul by a sunset radiance. Certainly there is no delusive realism in that, but isn't it something that actually exists?"

SELF PORTRAIT ~ Oil on board, 3¾" × 2⅞" (10cm × 7cm)

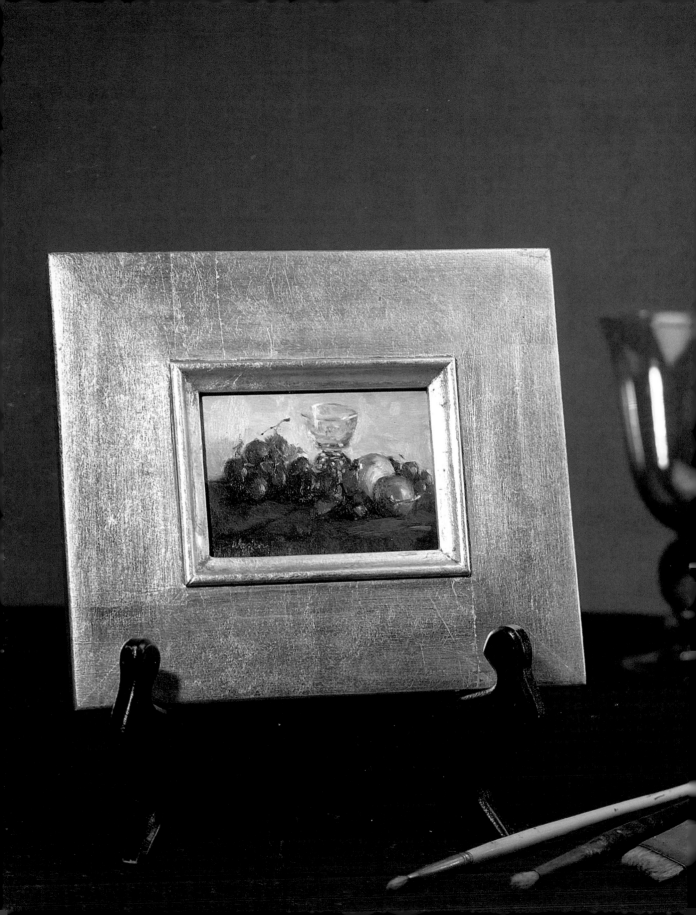

SMALL PAINTINGS
of your own

I REMEMBER BEING IN HONGNIAN ZHANG'S ART CLASSES AT THE Woodstock School of Art and marveling (along with the rest of the students) at his color sense, compositions and brushstrokes. When we asked how he did it, his answer was "100 yards of canvas. Just paint 100 yards and you will be a great artist." Of course this was a daunting proposition. What he was telling us was the same lesson people are imparting when they say, "How do you get to Carnegie Hall? Practice, practice, practice."

Many of my teachers encouraged us to paint smaller canvases in class so that we would be able to finish them in the allotted class time. Most art students have had the experience of starting a painting only to have to set it aside as the class switches to the next project. When I started doing small paintings, I got my chance to practice (and finish) many, many paintings without it costing me a fortune in canvases, paints, brushes or time. I wanted to paint small and also put everything I learned about painting into these small images. I discovered it was easier than I ever thought it would be. It's easier to see and make comparisons. It's easier on my body. It's cheaper to ship, and the finished paintings require less storage space. You need only a small area to work in. And to top it off, the learning curve is far, far shorter: You may not get to your 100 yards of canvas as quickly, but when you do, think of how many paintings and subsequent lessons you will have completed.

Capturing the Mood

One advantage to painting alla prima and finishing a painting in one session is that you don't have to try to be locked into the mood of a painting you started three days ago. Moods change frequently and are difficult to recapture, and the mood of a painting is a very influential to the finished work.

I did this painting a couple of days after I had returned from a meditation retreat. I wanted to transfer my newly quiet inner being into a still life painting. I picked objects I love: a glass bequeathed to me by a favorite aunt and some flowers that were given to me by a close friend. I chose a white cloth to symbolize the purity of the ashram (retreat center) environment I had just experienced. I kept the painting in a high key (light in value). The few dark tones were used to emphasize the center of interest (the large flower). The neutral tones of the glass (colorlessness) contrast with the colorfulness of the flowers. All the hues are kept subdued.

Materials List

OIL PAINTS

Chrome Green (Rodney Georgian), Sap Green (Winsor & Newton), Permanent Green Light (Winsor & Newton), Winsor Green (Winsor & Newton), Permanent Green Deep (Winsor & Newton), Raw Umber (Winsor & Newton), Cadmium Orange (Winsor & Newton), Winsor Red Deep (Winsor & Newton), Permanent Rose (Winsor & Newton), Indian Red (Winsor & Newton), Purple Madder (Winsor & Newton) and White (Permalba)

BOARD OR CANVAS

primed 3" × 4" (8cm × 10cm)

BRUSHES

no. 00 round, no. 0 round, no. 1 filbert, no. 2 filbert

OTHER MATERIALS

pencil, carbon paper, tracing paper, paper towels, palette knife

THE LANGUAGE OF BRUSHSTROKES

Just as everyone's handwriting is different and unique, each artist's style is his or her own, a culmination of experiences and work habits. Each of us grew up with a unique set of circumstances. We all have our personal favorites, our own goals and set of values. We see the world from our own perspective. Somehow this information gets transferred through our arms and hands and out our brushes. The more we paint, the more our "signature style" is enforced and recognizable. It's like finding a place for the first time. You might need to use MapQuest, ask directions and retrace your steps before you actually arrive. On the second visit, you might only need the map along for the trip. Before you know it, you might feel that you could get there with your eyes closed.

1 DRAW THE SCENE

Look at the objects as being massed together to form one unit, instead of as a collection of separate objects. This will help you fit them more easily onto the smaller board size. Look at the negative spaces. Adjust the objects so that the negative shapes are different and interesting. Overlap the objects in front of one another to help them fit and to establish depth.

After you have determined the overall structure and how it looks on the board, then it's time to look at the individual objects. Look for the basic geometric shapes. Remember to incorporate the cast shadows. Notice that entire objects are drawn. Draw through the overlapping flowers, and try drawing them as cubes rather then spheres. This helps the drawing immensely.

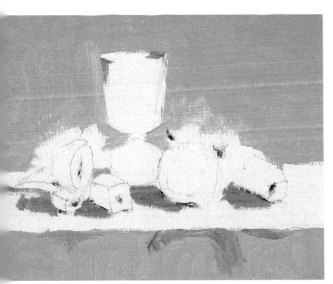

2 BLOCK IN THE INITIAL VALUES

Transfer your drawing to your canvas using carbon paper. Block in the background and plane in front of the table using a no. 2 filbert and a mixture of Indian Red, White and Permanent Green Deep. Use a no. 0 round with Purple Madder and Permanent Green Deep for the darkest part of the cast shadow, where the object touches the plane of the table. Paint the rest of the cast shadows with a no. 1 filbert using mixed Winsor Green, Permanent Rose and White. Use the same brush and color to paint the rim of the glass.

Squint when looking at this color and make sure it relates to the color of the table. It can be adjusted in later steps by using some of the shadow colors of the flowers. Again, use the same color to suggest some folds in the foreground plane of the fabric.

3 BEGIN PAINTING THE SUBJECTS

Use a no. 1 filbert to paint in the tabletop with a mixture of White, Chrome Green, Cadmium Orange, Sap Green and a touch of Raw Umber. Wipe the brush clean on a paper towel and use it to paint the shadow sides of the flowers with a reddish mixture of Permanent Green Light, Winsor Red Deep and White. Use the same dark tone of the cast shadows to paint the leaves and stems. Keep all the colors very warm to provide contrast with the leaf colors. The warmer the darkest tone is, the warmer the leaf colors can be and still have contrast. The glass is painted with mixed Permanent Green Light, Winsor Red Deep and White on the outside; add a bit more White and some Chrome Green to the mixture and paint the lighter color on the inside rear rim.

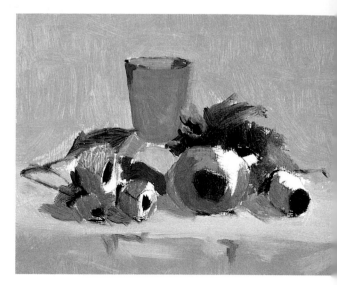

4 DEFINE THE COLORS

With a no. 1 filbert, paint the light hitting the flowers with mixed White, Indian Red and a touch of Permanent Green Light. Blend the flower color into the shadow tones to create a fluid transition between the shadow and light sides of the painting. Use both of these colors, the light and dark, in the leaves.

Lighten the tone of the glass using a no. 0 round with White, Winsor Red Deep and Permanent Green Light (which makes a beautiful, neutral gray), but keep the rim dark. Use this color and a no. 00 round for the design on the glass. Think of this design as wrapping around the glass, following the same angles as the ellipse that describes the rim of the glass. Add some warm tones in the foreground using a no. 0 round with White, Cadmium Orange and a bit of Sap Green. Use White, Chrome Green and Cadmium Orange, the complement of the tabletop color, to show how the light is hitting the table.

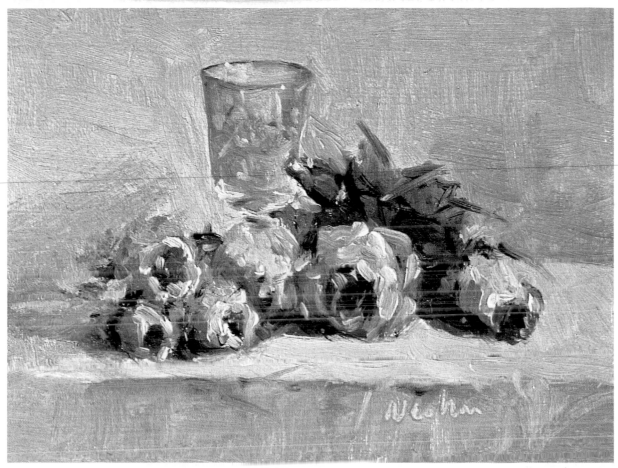

5 FINISH THE PAINTING

Incorporate a bit of the colors from the light side of the flowers into the shadow side. Less is more in this case. Use some of the shadow colors in the very dark centers of the flowers. Use some of the very dark tones in the large center flower to show its shape. The glass needs only a few selectively chosen highlights. The highlights can be brushed on boldly using a no. 00 round with White, Chrome Green and Cadmium Orange, but remember to follow the circular forms of the flowers. Scrape in the signature using the tip of a brush handle.

STILLNESS ~ Oil on board, 2⅞" × 3¾" (7cm × 10cm)

DETAIL

This flower, the focal point of the painting, has more detail than the other flowers. It is the largest and is surrounded by dark, complementary foliage, which makes it stand out. It's also directly facing the viewer.

Painting from Reference Photos

*F*or me, good photographic references should have one or more of the following elements: good composition, good value structure, unusual colors, interesting motifs or objects or the ability to serve as a reminder of a particular place. You can augment your own photos with subscriptions to magazines (I like *American Art Review, American Artist* and *Southwest Art*). I also save postcard announcements from my favorite galleries. You can put yourself on gallery mailing lists by visiting, phoning or e-mailing them.

You can arrange your reference collection according to season or by month and year. Now that digitalization has taken over film, your files can be on your computer instead of in a box. The more reference information you have, the better your paintings will be, and having a computer can give you access to a plethora of images.

The downside to working exclusively from photos is that you can lose the emotional connection to your subject and to the visual nuances that occur on a daily basis. To counterbalance this, I find taking long walks as often as possible keeps me in touch with nature.

Materials List

OIL PAINTS

Violet Grey (Old Holland), Winsor Blue (green shade) (Winsor & Newton), Cobalt Blue (Winsor & Newton), Mauve (blue shade) (Winsor & Newton), Blue Black (Winsor & Newton), Cadmium Orange (Winsor & Newton), Chrome Yellow (Rodney Georgian), Indian Red (Winsor & Newton), Mars Violet Deep (Old Holland), Scarlet Lake (Winsor & Newton) and White (Permalba)

BOARD OR CANVAS

primed 3"x 4" (8cm × 10cm)

BRUSHES

no. 0 round, no. 1 filbert, no. 2 filbert

OTHER MATERIALS

pencil, carbon paper, tracing paper, paper towels, palette knife

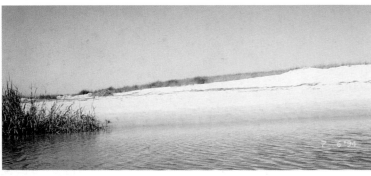

Photo by Christie Scheele

Reference Photo

1 CREATE YOUR DRAWING AND VALUE SKETCH

Stay true to the photo as much as possible, its value structure in particular. Here, the lightest lights are in the sand and the darkest darks are in the grasses. Vary the sizes of the main masses and overlap them to create depth and interest.

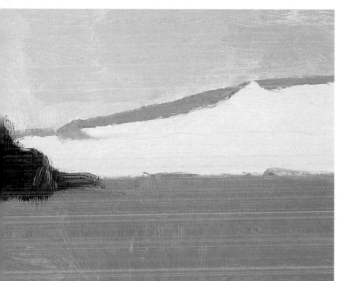

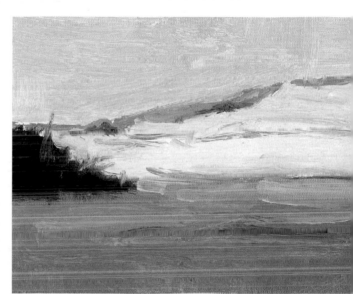

2 BLOCK IN THE INITIAL COLORS

Lay in the colors, using Mauve (blue shade) mixed with a touch each of White and Cadmium Orange with a no. 2 filbert for the water; Blue Black and Chrome Yellow with a no. 1 filbert for the bushes; Indian Red, White, Chrome Yellow and a bit of Mauve (blue shade) with a no. 2 filbert for the sand; and Cobalt Blue and Cadmium Orange with a no. 1 filbert for the distant land. Paint the sky with a mixture of White, Violet Grey and Cobalt Blue with a no. 2 filbert.

Keep it simple: landscapes are primarily just a background, middle ground and foreground. Paint the grass a cooler temperature than it appears in the photo to make it recede farther, and the water darker to make it come forward.

3 ADD DETAILS FOR DIMENSION AND DEPTH

Warm the sand in order to advance it closer to the viewer with a mixture of Mars Violet Deep, White and a touch of Violet Grey using a no. 1 filbert. Detail the water with warm tones of Mauve (blue shade) and a bit of Cadmium Orange. Add more Cadmium Orange to the mixture and add a darker tone to the dunes on the left; this will help model their form and show the direction of the light source.

DETAIL

This darker tone is used to show the direction of the light source.

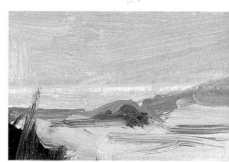

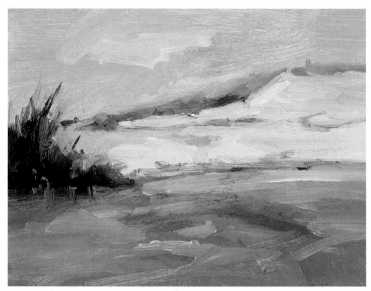

DETAILS

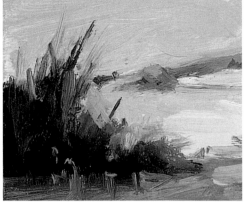

Lay lighter tones over the basic blocked-in shape of the grass. Use cool and warm tones of red and green to give this area the most detail of the painting, which brings it closer to the viewer.

4 FINISH THE PAINTING

When painting landscapes, follow the growth pattern of the trees and plants. Start at the bottom of the lefthand foliage and brush warm tones of Violet Grey mixed separately with Cadmium Orange and Chrome Yellow upwards with a no. 0 round. Go horizontally over the landforms with a no. 1 filbert using Winsor Blue and Chrome Yellow for the greenish color; add Scarlet Lake for the warm tone. Add the final details to the water with a no. 1 filbert: use Mars Violet Deep, Scarlet Lake and White for the pink hues and Mauve (blue shade) and Mars Violet Deep for the dark spots.

❧ DUNESCAPE ~ Oil on board, 3¾" × 2⅞" (10cm × 7cm)

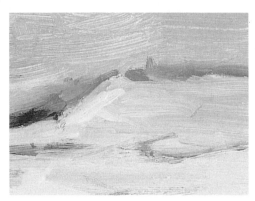

Add these light tones to balance the darks as well as to establish depth.

Adding Surface Interest

When I was painting large canvases, my teacher showed us how he would scrape off excess paint from his canvas after he did his initial block-in. I remember thinking, "Oh no—all that work and he's scraping it off! What is he thinking?" A ghost of the painting was left, but he didn't seem to care. He went right on ahead and continued in his usual way, mixing the darks and then the lights and paying attention to values and temperatures.

Use your palette knife to scrape and push the paint around after you've blocked in the entire painting. Be just as careful to get the correct values and color temperatures as you would be in a painting where you know you're not using the palette knife to scrape off paint.

Most of the paint will remain on the board. Take your palette knife on its edge and run it across the entire surface. You can do it in a haphazard way or be very methodical about it. In this demo, I started at the top left and crossed to the right. Do not wipe the knife: Keep the all paint on it so color gets deposited haphazardly about the painting. You can decide later if it's too much or chaotic and scrape it off then, or fill it in with a different color. Doing this makes me feel more painterly and not so fussy with the edges. It reminds me to paint the volumes. It also adds some mystery. (Soft edges help to create mystery in a painting.) It brings another dimension and adds texture to your painting.

Materials List

OIL PAINTS

Violet Grey (Old Holland), Winsor Blue (green shade) (Winsor & Newton), Cobalt Blue (Winsor & Newton), Mauve (blue shade) (Winsor & Newton), Indigo (Winsor & Newton), Cadmium Orange (Winsor & Newton), Mars Violet Deep (Old Holland), Chrome Yellow (Winsor & Newton), Scarlet Lake (Winsor & Newton), Scarlet Red (Winsor & Newton) and White (Permalba)

BOARD OR CANVAS

primed 3"x 4" (8cm × 10cm)

BRUSHES

no. 00 round, no. 0 round, no. 1 filbert, no. 2 filbert

OTHER MATERIALS

palette knife, pencil, carbon paper, tracing paper, paper towels

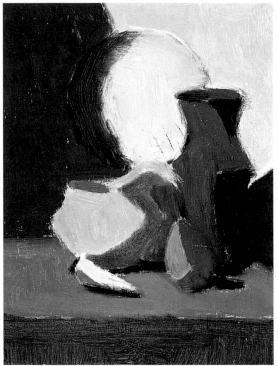

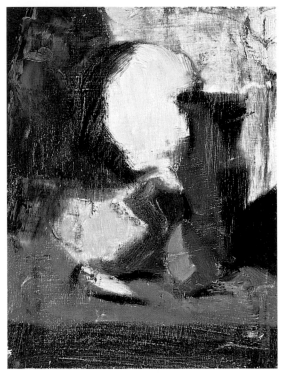

1 PAINT THE INITIAL COLORS

Mix together a fair amount of Violet Grey and Cadmium Orange. Use it with a no. 0 round to paint the shadow sides of the pitcher, orange and pepper. Add White to the mixture and paint the light side of the pitcher. For the table, use a no. 2 filbert, add Mauve (blue shade) to the mixture and paint the top, then add Cobalt Blue for the front.

Paint the dark side of the background using a no. 2 filbert with a mixture of Winsor Blue, Violet Grey, Mars Violet Deep, Cadmium Orange and White. Make a neutral white with Violet Grey, Chrome Yellow and Scarlet Lake and paint the light side with a no. 1 filbert. Begin the plate using a no. 1 filbert with Cobalt and Indigo on the dark side and Violet Grey, Chrome Yellow and White on the light side. Paint the vase with a no. 0 round using Indigo and Chrome Yellow, darkening it with Mars Violet Deep for the spots in shadow.

2 SCRAPE ACROSS THE CANVAS

Starting at the top left, sweep your palette knife cleanly across the canvas to the right. Continue across from top to bottom, only cleaning your knife on every other trip across. This way, the colors will be distributed throughout.

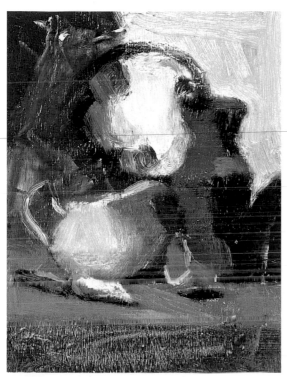

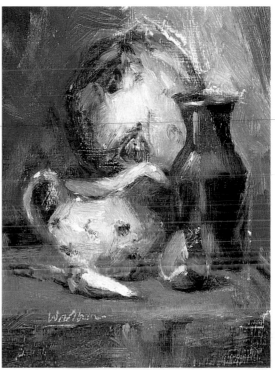

3 REDEFINE THE SUBJECTS

Reinforce the shape of the pitcher handle with a no. 0 round using Cobalt Blue, Cadmium Orange and White. Add more orange to this mixture and develop the front of the pitcher. Wipe the no. 0 round and use a mixture of Cobalt Blue and Chrome Yellow for the stem of the pepper. Lighten the mixture and paint the pepper itself.

Use a no. 1 filbert and a mixture of Mars Violet Deep and White to paint the front of the table and shadow side of the orange. Use Cadmium Orange and Scarlet Red with a no. 0 round for the front of the orange, and Winsor Blue and White with a no. 00 round to define its edge. Add spots of red to the plate with a no. 0 round and a mixture of Mauve (blue shade) and Scarlet Lake.

4 FINISH THE PAINTING

Highlight the vase with a no. 00 round and different values of Cadmium Orange, Mars Violet Deep and White. Wipe the brush and add the lightest highlights to the orange, pitcher, plate and pepper with a light mixture of Cobalt Blue and White. Add reddish spots to the pitcher with a no. 00 round and mixed Scarlet Lake and Cadmium Orange.

To create unity throughout the painting, add dabs of different values of Mars Violet Deep, Mauve (blue shade) and White in the background, tabletop and on the plate.

✻ LUNAR STILL LIFE ~ Oil on board, 2⅞" × 3¾" (7cm × 10cm)

DETAIL

The unique color mingling you get by scraping across the painting with the palette knife is apparent through the whole composition, particularly in the top of the background.

Seeing a Forest for the Trees

This was the view from my living room picture window in our weekend house in upstate New York. It was a house that my family loved and we were very sorry to have to leave. It's been about ten years since we lived there, and it's taken me all this time to have enough emotional distance to actually be able to paint this scene. The house was in the middle of three acres, and we loved to walk the property. I knew where each tree, rock, stump and animal was. I took many photos from many different angles.

Before doing this oil painting I'd drawn, pasteled and watercolored this scene, but never "massed" it. Now that it's been massed, it's paintable. When painting such a large subject on such a small surface, it's crucial that you draw the scene as one big shape instead of as individual objects. This will accurately transfer the size of what you're looking at to the size of your canvas.

Squinting is also a great tool for eliminating details, making sure you capture only the most important aspects of the big scene. When using a camera you could purposely put the background out of focus, or if you wear glasses you could take them off.

Materials List

OIL PAINTS

Chrome Green (Rodney Georgian), Sap Green (Winsor & Newton), Permanent Green Light (Winsor & Newton), Winsor Green (Winsor & Newton), Permanent Green Deep (Winsor & Newton), Raw Umber (Winsor & Newton), Cadmium Orange (Winsor & Newton), Winsor Red Deep (Winsor & Newton), Permanent Rose (Winsor & Newton), Purple Madder (Winsor & Newton) and White (Permalba)

BOARD OR CANVAS

primed 3" × 4" (8cm × 10cm)

BRUSHES

no. 00 round, no. 0 round, no. 1 filbert, no. 2 filbert

OTHER MATERIALS

Materials: pencil, carbon paper, tracing paper, paper towels, palette knife

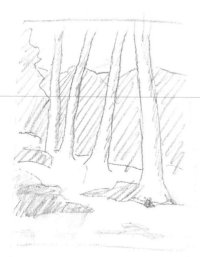

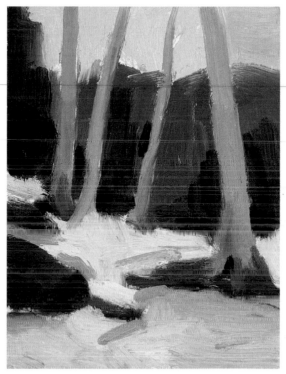

These trees are overlapped for depth; this one brushstroke shows which is in front.

1 CREATE A VALUE SKETCH

The challenge of this painting is creating an interior woodland scene by suggesting lots of trees rather than depicting every single one. Mass the trees in the background into one big shape, but define the ones in the foreground: They should be thick on bottom and thinner toward the top, and they should get smaller as they recede into the distance. Use a curved line at the base of the trees to show that they grow out of the earth, as opposed to resembling poles, which are a straight shot into the ground.

2 LAY IN INITIAL COLORS

Mass the background trees and mountains into one shape using a no. 2 filbert with Winsor Green, Permanent Rose and White. Use less White for the darker spots. Paint the dark brown areas with a no. 1 filbert using a mixture of Sap Green and Permanent Rose; darken it with Permanent Green Light for the darkest strokes. Add the lighter background snow with a no. 1 filbert and White with touches of Winsor Green, Permanent Rose and Winsor Red Deep. For the darker foreground snow, use the same brush with Raw Umber and White. Paint the sky with a no. 1 filbert and mixture of White, Permanent Rose and Winsor Green.

It's important to use the trees to show depth in the picture. The foreground tree on the right should be wider than the others, as well as lower in the composition. The trees on the left should overlap so the viewer can tell which is in front. Use a no. 1 filbert to paint the trees with a mixture of White, Raw Umber, Permanent Green Light and Winsor Red Deep.

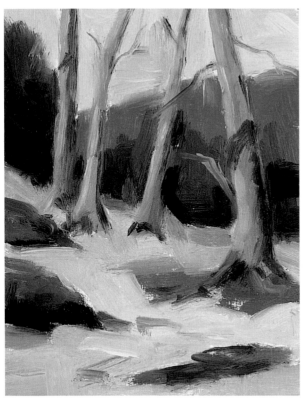

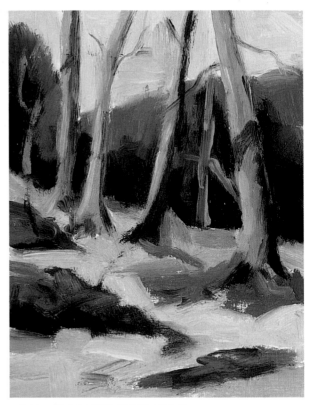

3 BEGIN TO MODEL THE FORMS WITH SHADOWS

Anchor the trees and rocks to the ground with dark Purple Madder using a no. 1 filbert. Begin adding cast shadows: Paint the rocks' shadows with Purple Madder and Permanent Green Deep using a no. 1 filbert. The cast shadows of the trees should follow the forms of the trunks and help round the trees. Use a no. 1 filbert with Raw Umber and a touch of Permanent Green Light. Add another land form in the foreground on the right to balance the composition. Use a no. 1 filbert with Raw Umber and Cadmium Orange.

4 PLACE BACKGROUND TREES

Add additional trees using a no. 1 filbert with a mixture of Raw Umber and White. Where the background is dark, add more Raw Umber to the mixture for the trees, and where it's light, add more White. Switch to the no. 00 round for the smallest trees and delicate branches. Add the warm touches, which make the cool trees stand out, using a no. 0 round and Cadmium Orange mixed with either Sap Green or Permanent Green Light.

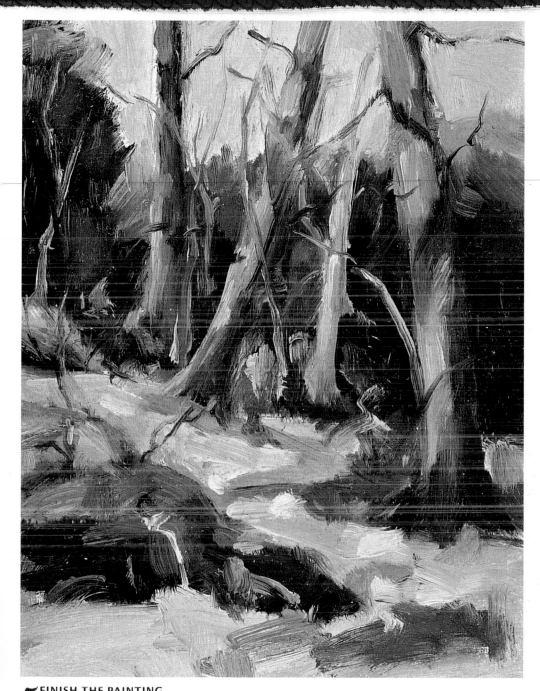

5 FINISH THE PAINTING

Define the background trees with a warm middle value of Cadmium Orange and Permanent Green Light using a no. 0 round. Use soft edges around them to create atmospheric perspective. Add some warm, light colors in the sky around the trees with a no. 1 filbert and Chrome Green, Cadmium Orange and White. Break up the background with a value of Sap Green and Permanent Rose that's slightly lighter than the base colors using your no. 1 filbert. Add Sap Green and Cadmium Orange to the right foreground tree with a no. 1 filbert.

Place intense colors in the foreground to bring it closer to the viewer. Use Cadmium Orange with a touch of Permanent Green Light and Permanent Rose with Winsor Green on a no. 1 filbert.

WOODLAND INTERIOR ~ Oil on board, 3¾" × 2⅞" (10cm × 7cm)

Using What Inspires You

While Picasso had his blue series, I seem to have had a red series. It all started when my husband and I went to our favorite Italian restaurant in Kingston, New York. I, of course, noticed the still life paintings of wine bottles and roses on the walls and the red tablecloths and napkins. Somehow one of those napkins found its way back to my studio, and I ended up using it in quite a few paintings.

Your paintings will be stronger if you've made an emotional connection with the objects you have selected. In my case, I think I brought home not only the napkin, but also my sense of taste and the contented feeling of being taken care of. The way to a man's heart may be through his stomach, but the way to a successful painting may be through as many sensory images and feelings as possible.

This painting is one of those in which I explored the red that inspired me. I used warm reds (orange-reds) and cool reds (purple-reds) to paint a red flower on a red fabric that changed in temperature and value depending on how the light hit it. The glass is a neutral color that enabled me to study what the red would look like as seen through the transparent object. The title of this painting could have been "How Much Red Can I Use Without Overdoing It?"

Materials List

OIL PAINTS

Chrome Green (Rodney Georgian), Permanent Green Light (Winsor & Newton), Winsor Green (Winsor & Newton), Permanent Green Deep (Winsor & Newton), Raw Umber (Winsor & Newton), Cadmium Orange (Winsor & Newton), Winsor Red Deep (Winsor & Newton), Permanent Rose (Winsor & Newton), Purple Madder (Winsor & Newton), Winsor Green Light (Winsor & Newton) and White (Permalba)

BOARD OR CANVAS

primed 3" × 4" (8cm × 10cm)

BRUSHES

no. 00 round, no. 0 round, no. 1 filbert, no. 2 filbert

OTHER MATERIALS

pencil, carbon paper, tracing paper, paper towels, palette knife

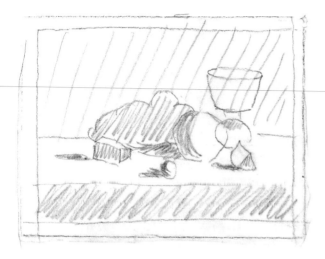

1 DRAW THE SCENE

Allow room in your drawing for where the frame will overlap it. Create a circular movement with your composition around the onion, the focal point. Draw the flower as a box, with top and side planes.

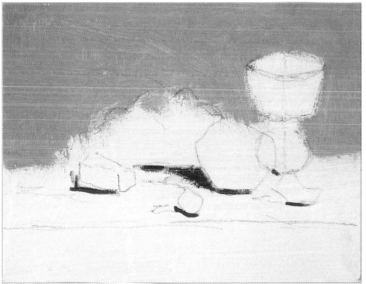

Drawing a center line down an object can help you draw equal shapes on both sides.

2 BLOCK IN THE MAIN VALUES

Paint the background with a mixture of White, Raw Umber, Permanent Rose and Winsor Green using a no. 2 filbert. Add in the dark values of the cast shadows using a no. 1 filbert with Purple Madder and Permanent Green Deep. The darkest value in the cast shadow should be where the object touches the table. It's important to add the cast shadows now and not in a later step, because dark tones stay darkest when they're painted directly onto the board, with no color underneath them. If there's a color underneath, the cast shadow will pick it up and be changed by it.

3 ADD COLOR TO THE SUBJECTS

Paint the grapes as one unit instead of individual shapes using a no. 1 filbert with Purple Madder and Permanent Rose. The glass should be painted solidly, with no division of light and shadow, with a light mixture of Winsor Red Deep, Winsor Green Light and White using a no. 1 filbert. Reflective and transparent objects such as this glass have only one tone, while nonreflective, opaque objects have light and shadow. That's just the way light acts when hitting them.

Paint the front of the tabletop with Purple Madder and Permanent Green Deep using a no. 2 filbert, and paint the tabletop with a no. 1 filbert using Winsor Red Deep and Purple Madder. Create the orange slice with a no. 1 filbert and Winsor Red Deep and Purple Madder. The light side of the onion is Winsor Red Deep, Permanent Green Light, Chrome Green and White, and the shadow side is Winsor Green and Permanent Rose. Use a no. 1 filbert for both sides.

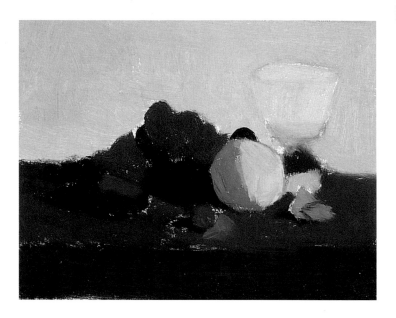

4 CREATE HIGHLIGHTS

In this step, add lighter tones to the right sides of the subjects to define where the light source is coming from. Add Winsor Red Deep and Cadmium Orange to the tabletop and the rose bud with a no. 1 filbert. Lighten Purple Madder with a touch of White and highlight the grapes with a no. 1 filbert. Use this same mixture with a no. 00 round on the inside edge of the glass to help define its rim. Highlight the orange slice with a no. 1 filbert using a mixture of Cadmium Orange and Raw Umber.

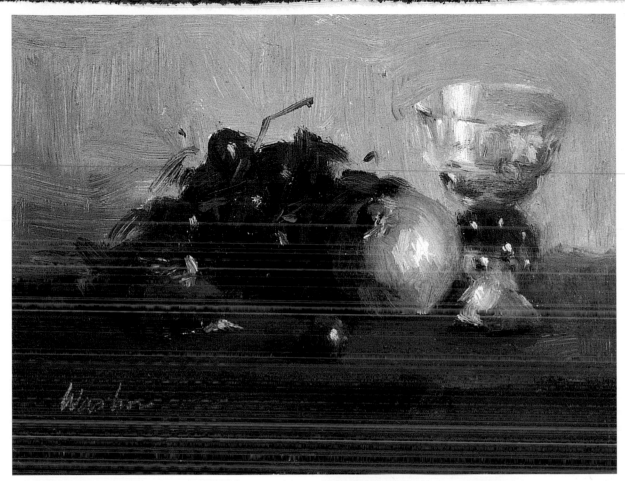

5 FINISH THE PAINTING

Drag some shadow tone into the background to push the area back in space (the blue will help it appear to recede) and also to break up the background's negative space. There should be high contrast at this point between the highlights and dark tones.

Add the finishing touches to the composition. Place brush-strokes of a warm mixture of Winsor Red Deep and Cadmium Orange throughout the tabletop to bring it forward. Finish the grapes with light dabs of Purple Madder and Permanent Green Deep. Use Cadmium Orange, Chrome Green and White with a no. 0 round for the lightest highlights on the onion and the inside of the glass.

❧ RED COMPOSITION ~ Oil on board, 2⅞" × 3¾" (7cm × 10cm)

DETAIL The onion gets the brightest highlight, since it's the focal point.

Learning from the Masters

I had been wanting to do a landscape using the yellow/purple palette for quite some time, and inspiration struck when I found a painting by Charles A. Platt, the American painter, architect, landscaper and etcher, in my collection of magazine clips (*American Art Review* is a great resource). I knew the composition would evolve as I started blocking in shapes, so I followed what the Platt painting evoked in me to see where it would lead.

Drawing inspiration from the work of the masters is good practice, and can result in great art. Painterly problems are all addressed when you look at a painting done by a master: trees are already massed, atmospheric perspective is employed, composition is designed and colors are integrated throughout the composition. In the painting that I was using for reference, I doubt that Platt used the yellow/purple palette—and I know he didn't do it on a 3" × 4" (8cm × 10cm) board—but it made me say, "How beautiful! I think I can learn more about painting trees by really studying this painting."

If your reference material speaks to you in some way, chances are you will be able to learn from it. Use the paintings of artists you admire to learn to use color in a different way, how to model more realistic forms or just to inspire you when the muse won't come.

Materials List

OIL PAINTS

Chrome Green (Rowney Georgian), Chrome Yellow (Winsor & Newton), Cadmium Yellow Deep (Grumbacher), Naples Yellow (Winsor & Newton), Raw Umber (Winsor & Newton), Violet Grey (Old Holland), Magenta (Winsor & Newton), Bright Violet (Old Holland), Purple Madder (Winsor & Newton), Blue Black (Winsor & Newton) and White (Permalba)

BOARD OR CANVAS

primed 3" × 4" (8cm × 10cm)

BRUSHES

no. 00 round, no. 0 round, no. 1 filbert, no. 2 filbert

OTHER MATERIALS

pencil, carbon paper, tracing paper, paper towels, palette knife

1 CREATE YOUR SKETCH

Vary the shapes in the background mountain range to make it appear more realistic. Block in the tree groups as one shape and indiviual trees on their own. The negative space on the right might feel unduly large, but you will add interest later with brushwork.

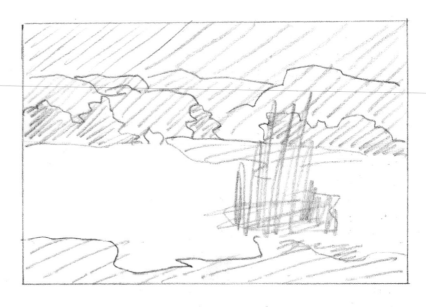

2 BLOCK IN THE VALUES

Create a very basic block-in; at this stage, all the values should be kept close together except for the darkest darks, which are all a mixture of Blue Black and Violet Grey applied with a no. 1 filbert.

Use a no. 1 filbert to block in the very forefront with Bright Violet and Naples Yellow. Add the dark brown, right-hand portion of the land with the same brush using Cadmium Yellow Deep and Bright Violet. Paint the sky with a no. 2 filbert using Violet Grey and Naples Yellow; wipe the brush and paint the light area of the ground Chrome Green and Violet Grey mixed with a touch of White. Switch back to the no. 1 filbert and add the mountains using Violet Grey and Naples Yellow.

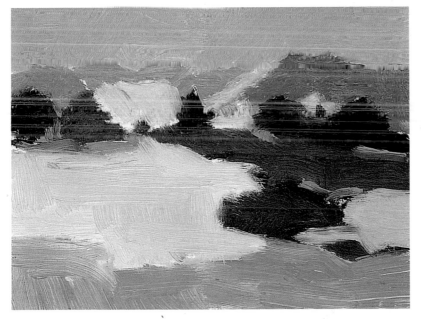

3 ADD LIGHT TONES

Add horizontal strokes of a warm, light mixture of Magenta and Naples Yellow to the sky with a no. 1 filbert. Apply the paint thickly to create texture and interest. Add more spots of the dark blue in front of the mountains with a no. 1 filbert.

Place more planes of color within the right-hand tree and grass areas to add interest and bring them forward. Dab mixtures of Violet Grey with Raw Umber and Blue Black, Chrome Yellow and Violet Grey through the area with a no. 1 filbert.

Begin adding more color to the open field on the right. With your no. 1 filbert, dab touches of light mixtures of Chrome Green, Cadmium Yellow Deep with White and Violet Gray with Naples Yellow throughout.

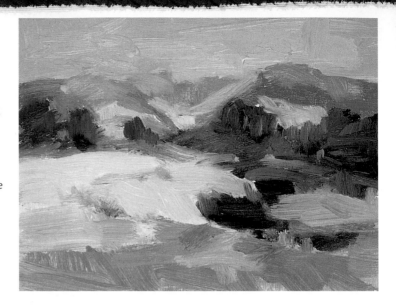

4 PLACE SPOTS OF INTENSE COLOR

The neutral colors you've been using up until this point set the stage for the more intense colors you're about to add. By placing careful spots of intense color throughout the foreground of a neutral painting, you can very effectively lead the viewer's eye.

With a no. 1 filbert, place the dabs of intense red with a bright mix of Magenta and Cadmium Yellow Deep. Add warm tones of Bright Violet and Cadmium Yellow Deep across the immediate foreground with horizontal strokes of a no. 1 filbert. Use the same brush to add the warmest tones to the right-hand foliage, the center of interest, with a deep mix of Purple Madder and Raw Umber.

DETAIL

These spots of intense red lead the viewer's eye from the back of the painting up into the right-hand foliage, the focal point.

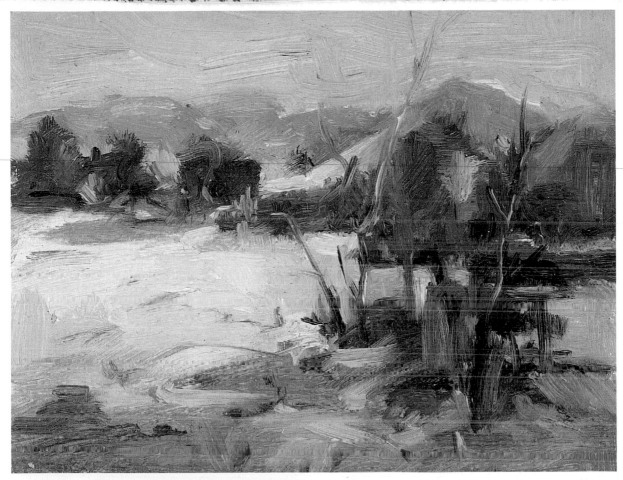

5 FINISH THE PAINTING

Bring some of the sky color across the mountains to soften the edge between them (adding atmospheric perspective) and also to increase the illusion of the mountains receding into the distance. Add your darkest darks to the focal point with a no. 00 round and a mixture of Purple Madder and Blue Black. The focal point, the foliage, should have the darkest colors and sharpest edges in the painting. Create lots of texture in the foreground with quick, varied brushstrokes of a no. 0 round heavily loaded with light mixtures of Cadmium Yellow Deep and Magenta.

HOMAGE TO CHARLES A. PLATT ~ Oil on board, 2⅞" × 3¾" (7cm × 10cm) ~ Collection of the artist

DETAIL
Use quick, varying brushstrokes, sharp, thin and thick, to build layers of color and texture that lend a painterly feel to the work.

Size Really Doesn't Matter

With this still life, I wanted to see how many objects I could fit into my small painting format. Since I started painting small, it's been my goal to be able to paint a lot of objects accurately and well, just like painters who work on large canvases. I don't want to be hampered just because I choose to paint within a restricted canvas size.

When you paint this many objects, it's a challenge not to get too fussy or detailed; I wanted to retain a loose, painterly feeling. I foreshortened the gold vase by laying it on its side, did a lot of overlapping and used my smallest flowers in order to make the most of the available painting surface. Compositional details can be very frustrating to work out on a canvas that's 3" × 4" (8cm × 10cm); after all, how do you capture the entirety of an object on a canvas half its size? It often requires creative maneuvering, but it can teach you so much about what's crucial to a painting and what can be discarded.

In the book *Hawthorne on Painting*, Charles Hawthorne said "What's important is not what we put on the canvas, but rather what painting the canvas puts in us." Working out artistic problems, whether they are self-made or inherent in the composition, addresses the need to continually learn from the painting process.

Materials List

OIL PAINTS

Chrome Green (Rodney Georgian), Sap Green (Winsor & Newton), Permanent Green Light (Winsor & Newton), Winsor Green (Winsor & Newton), Permanent Green Deep (Winsor & Newton), Raw Umber (Winsor & Newton), Cadmium Orange (Winsor & Newton), Winsor Red Deep (Winsor & Newton), Permanent Rose (Winsor & Newton), Indian Red (Winsor & Newton), Purple Madder (Winsor & Newton) and White (Permalba)

BOARD OR CANVAS

primed 3" × 4" (8cm × 10cm)

BRUSHES

no. 00 round, no. 0 round, no. 1 filbert, no. 2 filbert

OTHER MATERIALS

pencil, carbon paper, tracing paper, paper towels, palette knife

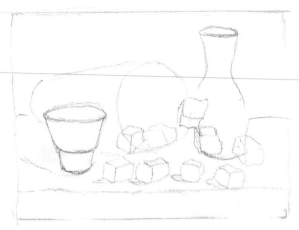

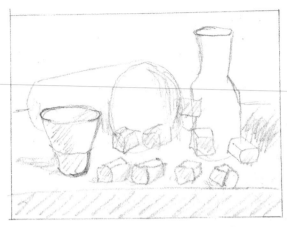

Value Sketch

1 CREATE THE DRAWING AND VALUE SKETCH

Remember to draw through the objects in order to render their shapes more accurately. You can draw the spheres in the forefront as cubes, which will help establish the planes. Also, there's no need to draw the flower on the cup that appears in the finished piece—it will be added after your block-in is complete.

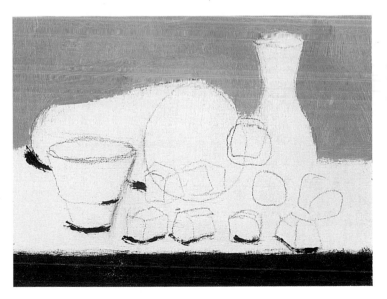

2 BLOCK IN THE INITIAL COLORS

Transfer your value sketch to the board using tracing paper, and start blocking in the composition. Paint the background using a no. 2 filbert and a mixture of Permanent Rose, Sap Green and White. It's necessary to get this color in first to help make subsequent color decisions; each color is affected by the others, and with this many objects, it's important to establish a base early on.

Now, add the darkest darks (cast shadows) using a no. 0 round with Purple Madder and Permanent Green Deep. They'll stay cleaner and darker if you leave them unaltered after this phase.

3 FINISH ESTABLISHING THE DARKS

Continue using darks to block in your composition. Be sure to relate the shadow side of each object to the color of the already established cast shadows; they should be almost the same value and temperature.

Add the dark red background color to the table-top using a no. 1 filbert with Purple Madder and Raw Umber. Wipe the brush, then add a mixture of Sap Green, Winsor Red Deep and Cadmium Orange to the light sides of the cup and greenish flowers. For the shadow sides, switch to a no. 0 round and Permanent Green Light and Winsor Red Deep.

Use a no. 0 round to paint the shadow sides of the reddish flowers with Purple Madder and Indian Red. Wipe the brush, then paint the light sides with Indian Red mixed with White and a touch of Sap Green.

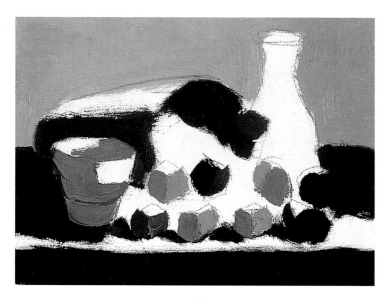

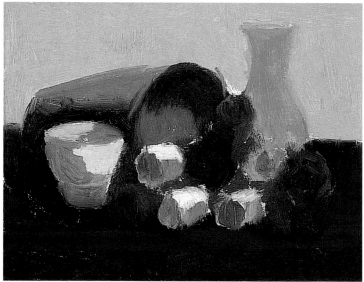

4 ADD THE LIGHT COLORS

Finish the block-in by adding the light colors. Use a no. 1 filbert with Winsor Red Deep mixed with just a touch of Permanent Green Light to paint the tabletop. Gray the mixture with more green and paint the vase and gray sides of the flowers. With a no. 00 round, paint the inside of the cup with a grey mixture of Winsor Green and Permanent Rose.

Use a no. 1 filbert to paint the inside of the bucket with Sap Green and Cadmium Orange. Wipe the brush and paint the outside of the cup with Chrome Green, Cadmium Orange and White. Add more White to that mixture and paint the light tops of the flowers.

5 ADD HIGHLIGHTS AND DETAILS

Place highlights on the glass vase using a no. 0 round with White, Chrome Green and Cadmium Orange. Make the flowers appear three-dimensional by adding light tones over the darker areas using a no. 0 round and circular strokes. Use Cadmium Orange and Winsor Red Deep for the red flowers; Chrome Green, Cadmium Orange, Raw Umber and White for the lightest flowers; and Indian Red, White and Chrome Green on the pink bud.

Add the floral design on the cup using a no. 0 round with Winsor Red Deep and Raw Umber for the large flower and Purple Madder for the smaller, darker bud.

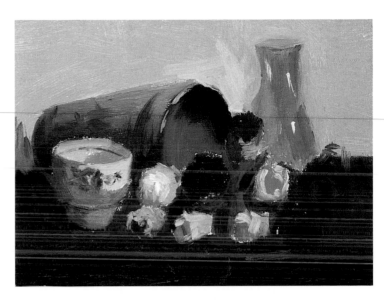

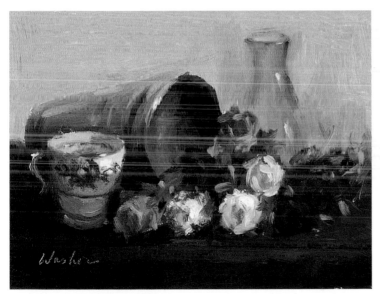

6 FINISH THE PAINTING

Highlight the bucket and the lip of the cup with a mixture of White, Chrome Green and Cadmium Orange using your no. 0 round. Wipe the brush, mix White and Indian Red, and apply it to the top rose. For the brightest spot on the other red roses, use a mixture of Indian Red and Cadmium Orange. For the lightest value in the green leaves, use a mixture of White, Chrome Green and Cadmium Orange and apply it with your no. 0 round.

❋ Vases, Roses and Yellow Cup ~ Oil on board, 2⅞" × 3¾" (7cm × 10cm) ~
Collection of the artist

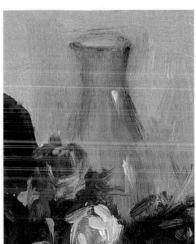

DETAIL
Make your vase appear more transparent by adding some of the background color to it and keeping the edges soft.

Making Color Your Subject

The challenge I set before myself with this painting was to be as brave as possible with my red/green palette. I wanted to make a painting that was recognizable as a landscape, but to be as free and unorthodox with my color choices as I could be.

It's important to follow the principals of designing and painting a landscape, even when your primary subject is color: value structure for the different planes, atmospheric perspective, lost and found edges. When you understand the principals of creating a landscape, you can develop and explore your color sense to your unlimited creative potential. When you're doing this, don't overwhelm the composition with details—let the colors take the stage.

One of the biggest challenges of this painting is maintaining just the right balance of neutral and saturated hues. Too much highly saturated color will be too bright and take over the painting—the intense colors won't stand out if all the colors are intense. How will your viewers know what's important? Keep the painting neutral until it's almost finished to avoid using too many highly saturated colors.

Materials List

OIL PAINTS

Chrome Green (Rodney Georgian), Sap Green (Winsor & Newton), Winsor Green (Winsor & Newton), Permanent Green Deep (Winsor & Newton), Raw Umber (Winsor & Newton), Cadmium Orange (Winsor & Newton), Winsor Red Deep (Winsor & Newton), Permanent Rose (Winsor & Newton), Indian Red (Winsor & Newton), Purple Madder (Winsor & Newton) and White (Permalba)

BOARD OR CANVAS

primed 3" × 4" (8cm × 10cm)

BRUSHES

no. 0 round, no. 1 filbert, no. 2 filbert

OTHER MATERIALS

pencil, carbon paper, tracing paper, paper towels, palette knife

1 MAKE THE DRAWING AND VALUE SKETCH

Create trees that have different lengths of tree trunks for interest, and overlap them to create depth. As in all landscapes, vary the size of the background, middle ground and foreground.

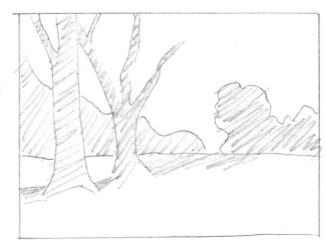

2 BLOCK IN THE COMPOSITION

Paint the sky using a no. 2 filbert and a mixture of Chrome Green and Indian Red. Wipe the brush and paint the foreground with a mixture of Sap Green and Cadmium Orange. Switch to a no. 1 filbert and paint the dark bushes and trees with a thin layer of Purple Madder and Winsor Green. Using this dark value for the trees makes a dramatic color contrast. Add the red tree on the left with a no. 1 filbert using Winsor Red Deep and Winsor Green. Create a light line at the horizon using a no. 0 round with Sap Green and Permanent Green Deep.

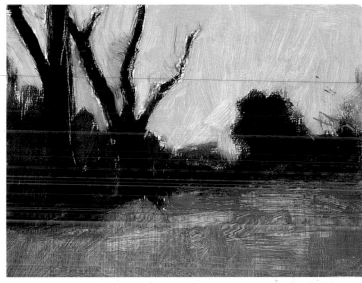

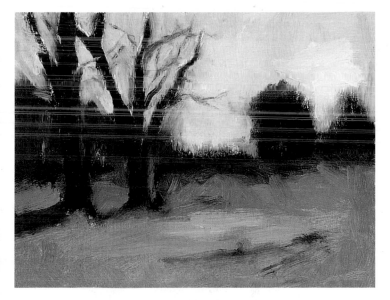

3 ADD SOME BRIGHT COLORS

At this stage, some bright, highly saturated colors are introduced to test the waters—the really intense colors will be added in the next step. Mix a blue made with Winsor Green, White and a touch of Permanent Rose, and sprinkle dabs of it throughout the composition with a no. 0 round. Add splashes of Sap Green mixed with a touch of Winsor Green in the middle ground with a no. 1 filbert, and add a warmer, more intense mixture of Winsor Red Deep, Chrome Green and White to the foreground with a no. 0 round.

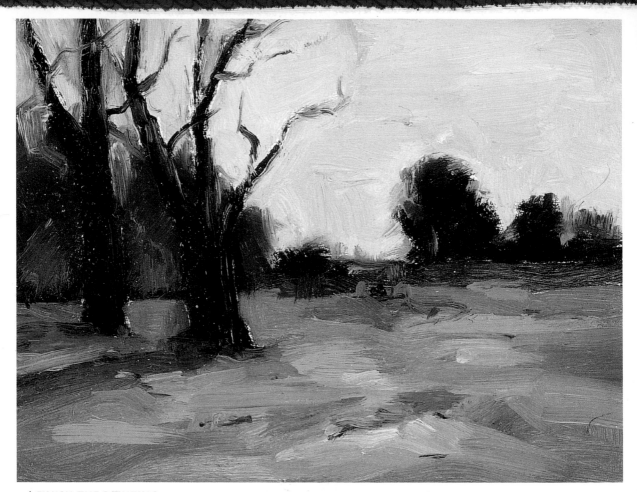

4 FINISH THE PAINTING

Layer the most intense colors in the painting on top of the existing colors with quick, lively brushstrokes and very thick paint. Use a no. 1 filbert to add a warm mixture of Raw Umber, White and Cadmium Orange to the sky; wipe the brush and add a cool mixture of Raw Umber and Winsor Green. Keep the edges in the sky soft to establish atmospheric perspective.

Add a neutral, warm mixture of Cadmium Orange, Raw Umber and White to the foreground—this will make the intense reds that complete the painting stand out. Mix Winsor Red Deep separately with Purple Madder and Cadmium Orange and add bright red spots in the foreground, being careful not to overwhelm the painting but adding enough color to create interest.

 LANDSCAPE #0467 ~ Oil on board, 2⅞" × 3¾" (7cm × 10cm)
~ Collection of the artist

DETAIL

In the foreground, this intense red color stands out against the more neutral shade. This interplay of bright against neutral helps establish color as the true subject of this landscape.

Painting the Planes for Realism

For a long time, I had difficulty rendering flowers realistically. They came out looking very confused, flat and/or lifeless. A friend offered some advice: Imagine the flowers as cubes or boxes. They will then have a definite top, side and bottom.

In essence, what she was telling me to do was to paint the planes—draw the flowers as though they were cubes with distinct sides, then paint each side a different color. Spheres can have planes, but they are not as easily seen as they are on cubes.

Since the light source in this painting is coming from the upper right, the top plane will be the lightest and the side facing the light will be next to lightest. The centers of the flowers are dark since the light is not penetrating there. You can round the form by adding another transitional plane between the top and side planes.

Materials List

OIL PAINTS

Chrome Yellow (Winsor & Newton), Cadmium Yellow Deep (Grumbacher), Naples Yellow (Winsor & Newton), Raw Umber (Winsor & Newton), Violet Grey (Old Holland), Magenta (Winsor & Newton), Bright Violet (Old Holland), Ultramarine Violet (Winsor & Newton), Purple Madder (Winsor & Newton), Blue Black (Winsor & Newton) and White (Permalba)

BOARD OR CANVAS

primed 3" × 4" (8cm × 10cm)

BRUSHES

no. 00 round, no. 0 round, no. 1 round, no. 1 filbert, no. 2 filbert

OTHER MATERIALS

pencil, carbon paper, tracing paper, paper towels, palette knife

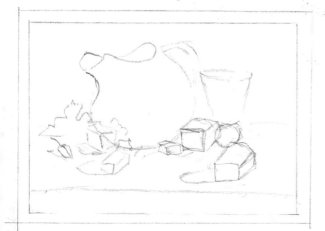

1 DRAW THE STILL LIFE
Draw the flowers as cubes to emphasize their planes—this will help when you begin applying their color, as a plane change indicates a color change. Use different sizes for the background, middle ground and foreground tabletop, and overlap the objects for depth. Don't forget to draw the cast shadows.

2 BLOCK IN THE MAIN COLORS

Use a no. 2 filbert to paint the background with a mixture of Violet Grey and Chrome Yellow. Paint the transparent glass with the same brush and color, making sure you can still see the pencil lines through the paint.

Create the cast shadow of the pitcher on the background fabric using a no. 1 filbert with a mixture of Blue Black, Chrome Yellow and Raw Umber. Use dark, warm Purple Madder with a no. 0 round for the other cast shadows.

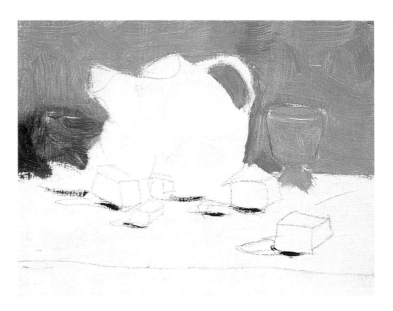

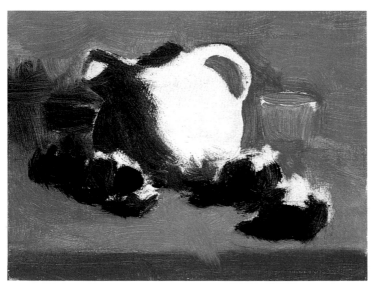

3 ADD DARKS TO THE OBJECTS

Paint the table a medium value of mixed Purple Madder and Raw Umber using a no. 0 round. The tabletop catches a lot of light, and its medium value will support the later highlights. Wipe the brush and paint the shadow side of the pitcher with Blue Black and Chrome Yellow.

The centers of the flowers do not recieve much light. Paint them with dark, warm Purple Madder and Raw Umber using a no. 0 round. Establish the flower buds with a no. 0 round using Cadmium Yellow Deep and Purple Madder.

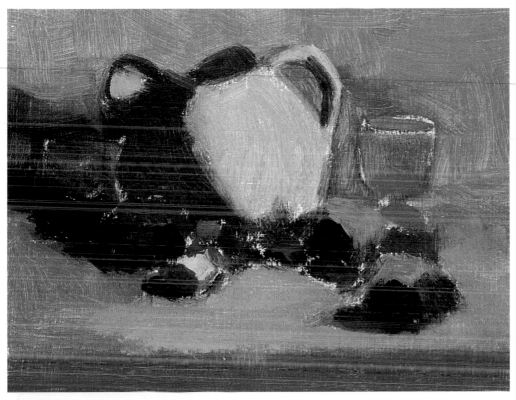

4 ADD THE LIGHT COLORS

Finish the block-in by adding the lighter values. Paint the light side of the pitcher using a no. 1 round with Naples Yellow and Violet Gray, keeping the edge between light and dark soft. Use a no. 1 filbert to paint the tabletop with Violet Gray and White.

Begin to develop the flower buds, using circular brushstrokes of a no. 0 round and keeping the top planes the lightest. For the flower on the far left, use a reddish mixture of Purple Madder and Cadmium Yellow Deep. Paint the small, light flower in front of it with Naples Yellow and Violet Grey. Use a pink mix of Naples Yellow, Bright Violet and Cadmium Yellow Deep for the middle flower, then add more yellow and paint the far right flower. Add the green leaves using a no. 0 round and mixture of Blue Black, Chrome Yellow and Cadmium Yellow Deep.

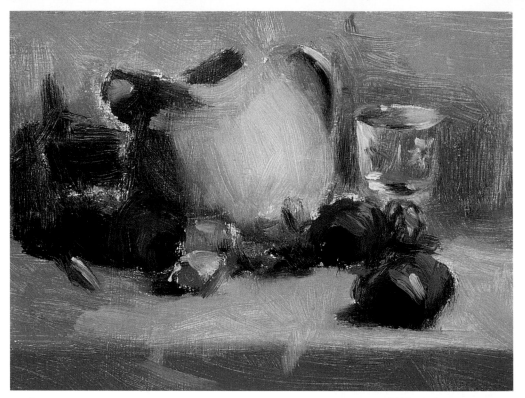

5 DEFINE THE FORMS

Round the pitcher and make it appear closer to the viewer by adding a warm streak of Magenta mixed with Cadmium Yellow Deep using a no. 0 round. Use the same brush and mixture for the two background flower buds, but use a warmer mixture of Magenta and Naples Yellow for the foreground flower on the right. Use this warmer color in the front of the tabletop to bring it closer to the viewer.

The glass should have few decorative details, but do add a little floral touch on the right side using the background color and a no. 0 round. Wipe the brush and paint the right side of the glass with the pitcher color. Lighten it slightly with white and paint the inside rim. Add a touch of a warm mixture of Magenta, Cadmium Yellow Deep and Raw Umber to the middle of the glass to make it appear round.

DETAIL
Make the glass appear realistic by layering light shapes over dark ones. Keep the highlights bright and the dark colors consistent with the object casting them.

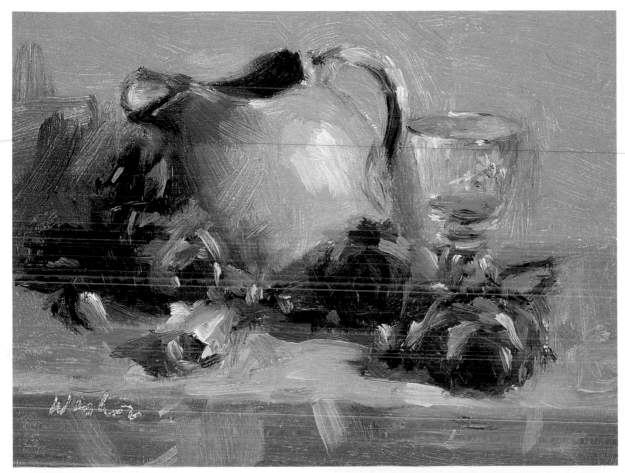

6 FINISH THE PAINTING

Add a dark mixture of Ultramarine Violet and Purple Madder to the inside of the pitcher with a no. 00 round. Highlight the pitcher using a no. 0 round with its complement, a mixture of Magenta, White and Violet Grey. Make sure to keep the edges soft so the highlight looks like light. Wipe the brush and round the glass with Magenta and Violet Grey, using lost edges to make the glass appear transparent.

Add a bright red mixture of Magenta and Cadmium Yellow Deep to the flowers on either side of the composition, then darken the mixture and apply it to the middle flower for contrast. Use circular strokes of a no. 0 round to define the flower's shape.

YELLOW PITCHER AND JANET'S ROSES ~ Oil on board, 2⅞" × 3¾" (7cm × 10cm) ~ Collection of the artist

DETAIL
Use circular brushstrokes to round the flowers and define their shapes and petals.

Capturing the Familiar

This reference photo is a scene near Woodstock, New York, that I used to pass almost every weekend. Being familiar with a particular place makes it easier to experiment with different color statements within the same framework. It's similar to advice that many writers get: Write about what you know. It's good practice for painters to paint what they know.

Being familiar with a place is like visiting a close friend—you don't have to worry about formalities, you can just relax and let the conversation flow of its own accord. It's also like seeing a movie for the second time—you notice so much more and come away feeling more fulfilled.

When I really know a place, in particular if I have experienced it in all four seasons, I feel I can become more experimental with color. Once I've figured out the values and know exactly what belongs where, I know I can substitute any other color as long as it's the same value and the painting will still read as a landscape.

Materials List

OIL PAINTS

Chrome Green (Rowney Georgian), Chrome Yellow (Winsor & Newton), Cadmium Yellow Deep (Grumbacher), Naples Yellow (Winsor & Newton), Raw Umber (Winsor & Newton), Violet Grey (Old Holland), Magenta (Winsor & Newton), Bright Violet (Old Holland), Purple Madder (Winsor & Newton), Blue Black (Winsor & Newton) and White (Permalba)

BOARD OR CANVAS

primed 3" × 4" (8cm × 10cm)

BRUSHES

no. 00 round, no. 1 filbert, no. 2 filbert

OTHER MATERIALS

pencil, carbon paper, tracing paper, paper towels, palette knife

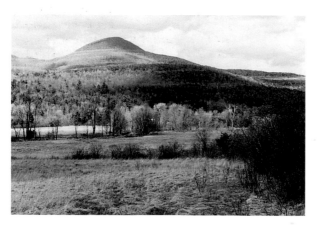

Reference Photo
I took this photo of the Catskill Mountains near my home in New York. This is a scene I have seen countless times, and I know its composition and value structure so well I can freely experiment with the colors in my painting without compromising the major components.

1 CREATE THE DRAWING AND VALUE SKETCH

Set the highest peak of the mountain off to one side, not dead center, to make the composition more interesting. Vary the space between the trees, and make sure the grasses in the foreground are bigger than the trees in the background to create the correct perspective. Add the dotted lines around the edges to see where the painting will end when framed.

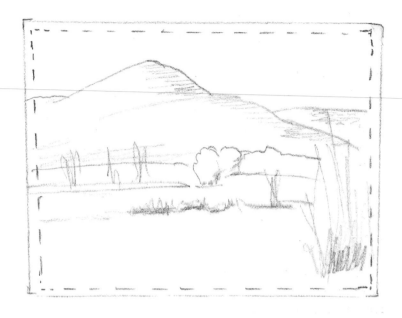

2 BLOCK IN THE DARKS

Paint the sky using a no. 2 filbert and a light mixture of Violet Grey, Chrome Green, Raw Umber and White. Make a slightly darker mix of Chrome Green and Raw Umber, and use a no. 1 filbert to block in the distant mountain range. Add the light strip in the middle ground with a no. 1 filbert and a mixture of Chrome Yellow, Violet Grey and White. Darken this mixture slightly with Naples Yellow and add the center foliage.

Use the darkest and most intense color in the foreground: Apply a dark mixture of Raw Umber and Purple Madder in the right foreground using a no. 1 filbert. At this stage, keep all the colors soft and the color scheme simple.

3 ADD THE CENTER OF INTEREST

Create the center of interest by adding a bright, intense plane of Chrome Yellow, Cadmium Yellow Deep and a touch of Violet Grey in the middle ground with a no. 1 filbert. Keep the mountain range soft, but add some darks in the middle ground using a no. 1 filbert and a dark mixture of Blue Black and Cadmium Yellow Deep.

Add more intense colors in the foreground and begin defining the trees using a no. 1 filbert and a highly saturated mixture of Magenta and Raw Umber.

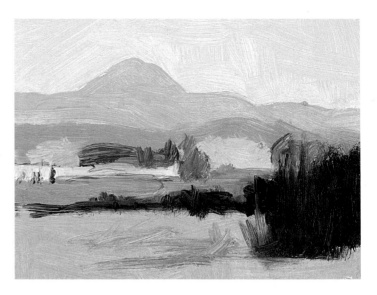

4 COOL AND SOFTEN THE COLOR SCHEME

Continue building the landscape—you can grow trees where you need to fix the composition. At this point, all the colors need to be slightly lightened. Apply a light mixture of Cadmium Yellow Deep, Raw Umber and White to the mountains—this will both keep them in the background and show which direction the light is coming from.

The right foreground was a bit too overbearing. Use a lighter tone of Cadmium Yellow Deep, Bright Violet and Chrome Green over it with a no. 1 filbert to soften the area. Use the same brush with a mix of Raw Umber and Magenta to grow a tree nearby to help balance the composition.

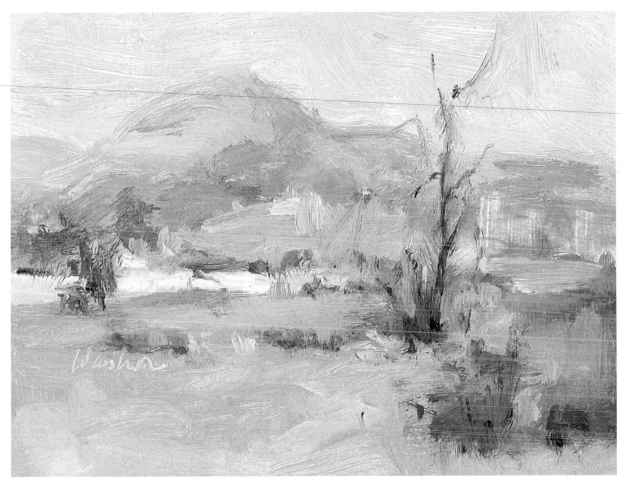

5 FINISH THE PAINTING

Put down the paint in this step quickly, but leave some areas uncluttered. A good painting has quiet places where the viewer's eyes can rest. Use a no. 1 filbert to apply a mixture of Cadmium Yellow Deep and Raw Umber—which should be a color close to the yellow tones in the foreground—to add interest and color harmony. Keep the edges of the sky and mountains soft to give the feeling of atmospheric perspective.

Use expressive brushstrokes of a no. 00 round in the foreground to add texture and expression with a mixture of Chrome Green, White, Naples Yellow and Raw Umber. Wipe the brush and use Raw Umber to define the tree branches. Use the handle of the brush to scratch your signature (keep it small!) in a quiet area of the composition.

SICKLER ROAD ~ Oil on board, 2¾" × 3½" (7cm × 9cm) ~Collection of the artist

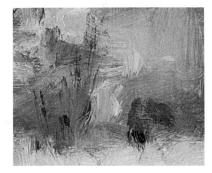

DETAIL

Brushstrokes are an important element in composition. Use them to lead the viewer's eyes where you want them to go.

Thinking of van Gogh (Being Influenced by Exhibits)

*I*used to be an avid reader, but since I began painting full time I only read art-related books and magazines or works by my meditation teachers and fellow students. I remember reading somewhere that painters should refrain from reading novels while working. I've found that I can become too influenced by someone else's story and get sidetracked from my own. Since I'm always working (or thinking about working), I've gotten out of the habit of reading novels.

Recently, I was about to travel across the country to teach a workshop and needed to occupy my travel time with a book. I decided to read Vincent van Gogh's letters. This happened to coincide with an exhibition at The Metropolitan Museum of Art in New York called *Van Gogh: The Drawings.*

I wasn't prepared for the depth of his humanity and his ability to convey his thoughts into words. One can't help but be amazed, humbled and inspired after seeing his drawings and reading his letters. What a gift that we have his letters to his brother!

The museum had a corresponding installation entitled *In Line with Van Gogh* that exhibited works Van Gogh had seen and been influenced by, as well as examples of works of artists who had been inspired by him. I remember reading in his letters how much he admired Rembrandt, Millet, Corot and Daumier. He and his brother, Theo, were avid collectors. Like van Gogh was, always be on the lookout for artists whose work can inspire you to create in new and exciting ways.

Materials List

OIL PAINTS

Violet Grey (Old Holland), Winsor Blue (green shade) (Winsor & Newton), Cobalt Blue (Winsor & Newton), Mauve (blue shade) (Winsor & Newton), Indigo (Winsor & Newton), Chrome Yellow (Winsor & Newton), Cadmium Orange (Winsor & Newton), Scarlet Lake (Winsor & Newton), Mars Violet Deep (Old Holland), Blue Black (Winsor & Newton) and White (Permalba)

BOARD OR CANVAS

primed 3"x 4" (8cm × 10cm)

BRUSHES

no. 00 round, no. 1 filbert, no. 2 filbert

OTHER MATERIALS

pencil, carbon paper, tracing paper, paper towels, palette knife

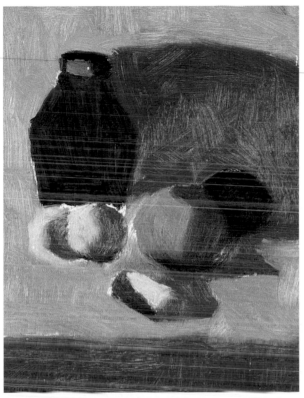

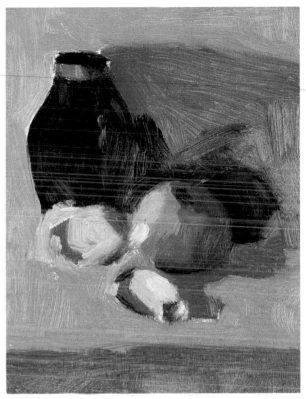

1 BLOCK IN THE MAJOR SHAPES

Since the vase is a reflective object, paint it with one tone using a no. 1 round and a mixture of Cadmium Orange, Chrome Yellow, Violet Grey and White. Use the same brush (wiped clean between color mixtures) to paint the rest of the objects: the onions and flower are Chrome Yellow and Violet Grey toned with White; the foreground orange is Cadmium Orange, Violet Grey and Mars Violet Deep; and the background orange is is the same as the other, darkened with more Mars Violet Deep.

Paint the background using a no. 2 filbert and a mixture of Violet Grey, Chrome Yellow, Mauve and White. Now it's time to add the cast shadows. With a no. 2 filbert, add the shadow cast by the whole arrangement with Violet Grey, Cobalt Blue and Indigo. With a no. 00 round, paint the shadows of the onion, orange and flower with Mars Violet Deep and Mauve (blue shade). Add the yellow band at the top of the vase with a no. 1 round and Mauve (blue shade) mixed with Chrome Yellow.

2 BEGIN ROUNDING THE OBJECTS

At this stage in the painting, it's crucial to be looking for plane changes: Every plane change means a new color. Using a no. 1 round with Mars Violet Deep, add the dark accents to the vase, orange and flower. Apply the light accents on the vase, onion and flower with the same brush using Chrome Yellow and Violet Grey toned with White. Use a no. 1 round to put the vibrant spots on the oranges with Cadmium Orange with just a hint of Cobalt Blue for the foreground orange and much more Cobalt Blue for the one in the background. Add the green shape in the background and green accents using a no. 1 filbert with Winsor Blue and Chrome Yellow.

DETAIL

For these highlights, the brightest in the painting (as they're on the focal point), use fast brushstrokes with a lot of paint. Try to place them without smudging and be sure to use a clean brush so the color isn't muddied.

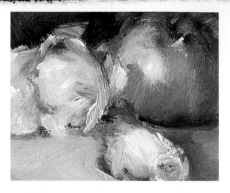

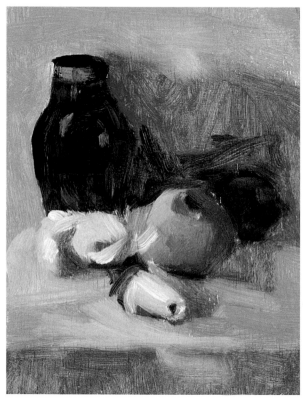

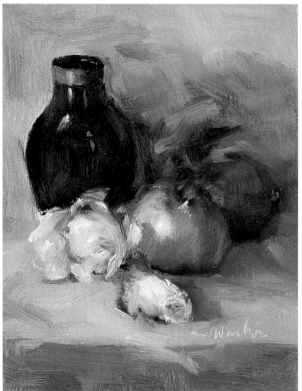

3 ADD WARM TONES

With an eye still toward plane changes, add warm tones throughout the painting with a no. 1 filbert—it will make the foreground advance, and using a small amount in the background will unite the composition.

With a mixture of Cadmium Orange and Cobalt Blue, add warm touches to the oranges and the front of the table. Wipe the brush and apply Cobalt Blue and White to the vase. Use Blue Black and Chrome Yellow for warm accents on the onion and leaves of the flower. Scatter touches of a pinkish mixture of Cadmium Orange, Scarlet Lake and White on the tabletop and in the background.

4 FINISH THE PAINTING

Create soft edges in the background to push the objects back, and keep the edges in the foreground relatively hard. Add dark highlights to the green in the background using a no. 1 round and a mixture of Blue Black, Chrome Yellow and Mars Violet Deep. With the same brush add touches of Mars Violet Deep to the oranges, the green area close to the vase and the backside of the flower and onion. With a no. 1 filbert, add Indigo and Mars Violet Deep to the front of the table.

Now, add the bright highlights to the objects with a no. 0 round, wiped clean between colors. Use a mixture of Chrome Yellow, Cadmium Orange and White on the vase and the orange. Save the lightest, most striking highlights for the focal point—the flower and onions. For these, use the same mixture brightened with more White.

※ VAN GOGH ONIONS ~ Oil on board, 3¾" × 3" (10cm × 8cm)

Going Where the Subjects Take You

I had planned to complete this painting using objects I had worked with on a much older composition. I was under some pressure for a project (this book) and thought the painting would go faster if I used a subject I had already worked with. Plus, I figured it would be interesting to see the difference in my style since so much time had passed.

Instead of liking the setup, the two bottles I had chosen struck me as being too close to the same height— the hunt for subjects had begun. A copper mug in my cabinet of potential still life subjects caught my eye as a good center of interest, then I focused my search on good supporting objects, looking for differences in color, height, size and texture.

Two hours later I had tried almost every bottle, cup and vase in my collection. I moved the objects around, looking at the negative spaces, the reflections that each object cast on its neighbors and how the color of each object enhanced or detracted from the composition. Finally the objects seemed to like where they were. They even began talking to each other and smiling. I could feel the energy. I overlapped the objects to be able to get more into the composition, but I also got the feeling that another reason I did this was because I like to think of the objects as liking each other and wanting to be close. (Have I done too many still lifes? Is this weird?)

It's very important to take the time to arrange your still life to exactly how you want it. The objects need to be interesting in and of themselves, but they also have to work together to make a successful painting. Setting up a still life is when you design the painting. Look at the pattern of lights and darks, compositional movement, center of interest and color harmony.

Materials List

OIL PAINTS

Violet Grey (Old Holland), Winsor Blue (green shade) (Winsor & Newton), Cobalt Blue (Winsor & Newton), Mauve (blue shade) (Winsor & Newton), Indigo (Winsor & Newton), Chrome Yellow (Winsor & Newton), Cadmium Orange (Winsor & Newton), Scarlet Lake (Winsor & Newton), Mars Violet Deep (Old Holland), Blue Black (Winsor & Newton), Naples Yellow (Winsor & Newton), Purple Madder (Winsor & Newton), Chrome Green (Rowney Georgian) and White (Permalba)

BOARD OR CANVAS

primed 3"x 4" (8cm × 10cm)

BRUSHES

no. 00 round, no. 0 round, no. 1 filbert, no. 2 filbert

OTHER MATERIALS

pencil, carbon paper, tracing paper, paper towels, palette knife

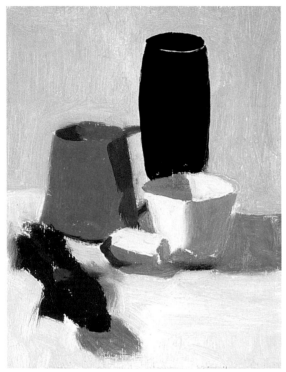

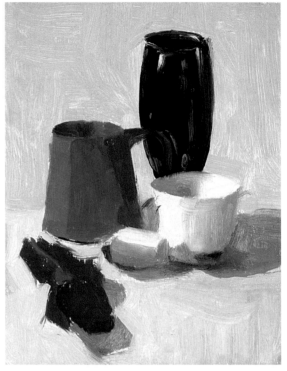

1 BLOCK IN THE MAJOR SHAPES

Remember, at this stage you want to exaggerate the lights and darks to act as the "value plan." Use a no. 1 filbert, wiped clean between colors, to paint the objects. Since the vase is a reflective object, it should be painted with only one tone at this stage: use a dark mixture of Indigo and Winsor Blue (green shade). Paint the cup and light flower bud with a mixture of Winsor Blue, Chrome Yellow and Scarlet Lake. The lighter accents are Naples Yellow, White and Violet Grey.

Paint the copper mug with a mixture of Cadmium Orange, Mars Violet Deep and Cobalt Blue. Its dark accents are Mars Violet Deep, Cobalt Blue and Purple Madder. The red rose is Scarlet Lake and Mauve (blue shade) for the bud and Blue Black, Chrome Green and Scarlet Lake for the petals.

Switch to a no. 2 filbert and paint the background Winsor Blue and Chrome Yellow. Use the same brush to paint the table Naples Yellow and Violet Grey. Add the cast shadows uaing a no. 1 filbert and a mixture of Cobalt Blue, Cadmium Orange and Violet Grey.

2 BEGIN ROUNDING THE OBJECTS

As usual, begin adding transitional colors between plane changes. Drag light colors into dark and vice versa to establish smooth transitions.

Use a no. 0 round and add reflections on the blue vase with the color of the copper mug. Wipe the brush clean and apply a light mixture of Cobalt Blue and Violet Grey for the vase's higlights.

The highlight on the copper mug is done in two layers with a no. 1 filbert: the first is a light blue made with Cobalt Blue and White, and on top of that is a mix of Cadmium Orange, Scarlet Lake and White. Darken the right side with Mars Violet Deep, Cobalt Blue and Cadmium Orange.

Switch to a no. 0 round and add touches of Winsor Blue and Cadmium Orange to the red rose's petals and the lighter rose bud. Darken the cast shadows using the same brush and a mixture of Cobalt Blue and Indigo.

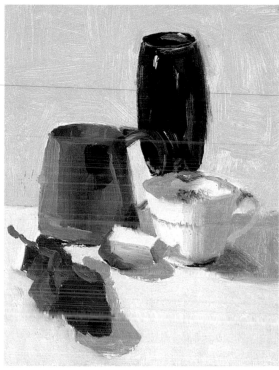
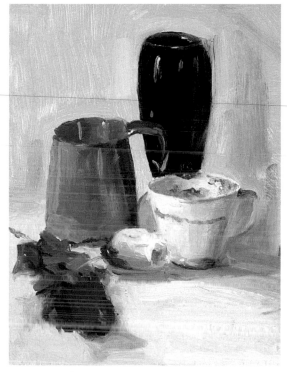

3 ADD THE DETAILS

Now that the lights and darks are established, you can begin adding the details. In particular, more darks are needed in the copper mug, the base and handle of the cup and the inside of the white flower.

With a no. 1 filbert, apply dark touches of Mars Violet Deep and Indigo to the copper mug. Blend the different tones and use this mix to make a thick brushstroke along the mug's bottom. Using a no. 0 round, place a bright streak of Cadmium Orange, Scarlet Lake and White down the mug with one long, fast stroke.

Using the same brush, color the top of the red rose bud with Scarlet Lake and Cadmium Orange. Wipe the brush and apply Scarlet Lake to the inside of the cup to establish the design. Darken it with a bit of Mars Violet Deep and apply it to the lip of the cup. Use the same brush to paint the yellow band inside and outside the cup with Chrome Yellow and Mars Violet Deep. Switch to a no. 00 round and add the dark accent at the bottom of the cup with a mixture of Scarlet Lake and Mauve (blue shade).

4 FINISH THE PAINTING

Lighten the tones in the cup using a no. 0 round and a mixture of White, Chrome Yellow and Scarlet Lake. Use the same brush to add the lightest spot into the painting, the White and Chrome Yellow highlight on the light rose bud.

Warm the tones on the tabletop with a no. 1 filbert and a mixture of White, Scarlet Lake, Cadmium Orange and Violet Grey. Drag this warm tone up into the background next to the vase. Soften the cast shadows on the table by blending, starting from the outside and using fast, painterly strokes.

Finally, brighten your focal point and add in the final darks. Highlight the copper mug with a vibrant mixture of White, Scarlet Lake and Cadmium Orange using a no. 0 round. Use the same brush to darken the petals of the red rose with a mixture of Mauve (blue shade) and Mars Violet Deep. Wipe the no. 0 round clean and darken the right side of the background and cup with mixed Winsor Blue, Chrome Yellow and a touch of Scarlet Lake.

STILL LIFE WITH COPPER MUG ~ Oil on board,
3¾" × 3" (10cm × 8cm)

The Self-Critique, Part I

*C*ritiquing yourself is an integral part of the creative process. No matter what you're creating, you inevitably have to decide which parts need adjusting. I know painters who don't let anyone else in their studio, and also those who live for as many group or individual critiques as possible.

Some of the best advice I ever heard was from a friend who said to just keep painting and let other people worry about whether it's good or not. Taking the middle road—getting feedback only from trusted and sensitive people—makes the most sense to me. I heartily include my therapist in this group even though he constantly reminds me how color blind he is. While I'm on the subject, maybe the best advice I can give you is to get the best therapist you can find. A therapist is an important part of an artist's tools.

Judging your work is different from studying it and being able to know what to do to make it better. Most of the time I can determine what needs to be corrected in a painting. If I get stuck, I usually ask whoever is around: Hearing myself talk about what is bothering me about the painting will usually solve my dilemma. Of course, if one of my artist friends is nearby, so much the better. And of course, an enthusiastic fan is always a welcoming bonus to the creative soul. Amass as many kindred, supportive people as possible.

Developing a healthy, constructive style of self-critiquing—one that won't prevent you from getting back into the studio and back to the proverbial drawing board—is crucial to your growth as an artist.

I had gotten into the habit of not using dark backgrounds in my still lifes. (Habits eventually become interpreted as your style.) Dark fabrics are usually difficult for the person taking the reference photos to

Materials List

OIL PAINTS

Chrome Green (Rowney Georgian), Chrome Yellow (Winsor & Newton), Cadmium Yellow Deep (Grumbacher), Naples Yellow (Winsor & Newton), Raw Umber (Winsor & Newton), Violet Grey (Old Holland), Magenta (Winsor & Newton), Bright Violet (Old Holland), Ultramarine Violet (Winsor & Newton) Purple Madder (Winsor & Newton), Blue Black (Winsor & Newton) and White (Permalba)

BOARD OR CANVAS

primed 3" × 4" (8cm × 10cm)

BRUSHES

no. 00 round, no. 0 round, no. 1 filbert, no. 2 filbert (Robert Simmons Series)

OTHER MATERIALS

pencil, carbon paper, tracing paper, paper towels, palette knife

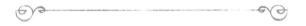

work with. Dust gets caught in the ridges and inevitably shows up as white specks in slides and prints. (My photographer, Al, uses a lint roller on them before photographing them.)

However, I was attracted to this velvety, dark purple fabric. It really set off the sunflowers and I decided to go out of my artistic comfort zone and use it instead of my usual medium- or light-value fabric. It didn't work out exactly as I hoped: Another reminder that the artistic journey is not linear.

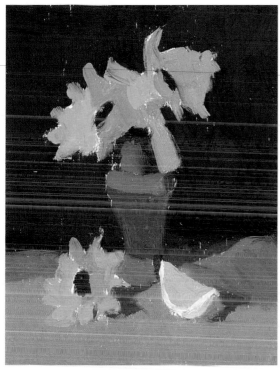

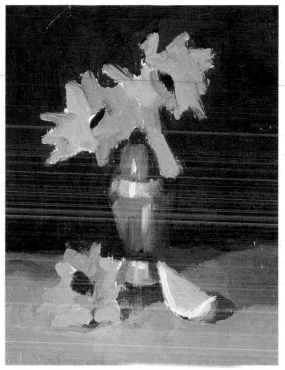

1 BLOCK IN THE BASIC SHAPES

I began the painting like any other, by blocking in the basic value structure and major shapes. Using a no. 1 filbert, I painted the vase with a mixture of Blue Black, Ultramarine Violet and Chrome Yellow. With the same brush, I painted the light side of the flowers Chrome Yellow, Cadmium Yellow Deep and Violet Grey. The dark side is a mixture of Purple Madder, Blue Black and Bright Violet. Wipe the brush clean and paint the lemon Chrome Green, Chrome Yellow and White.

Switch to a no. 2 filbert and paint the background with a mixture of Purple Madder, Blue Black and Bright Violet. (Use the same color tinted with a little Raw Umber for the centers of the flowers.) Wipe the brush on a paper towel and use it to paint the tabletop a mixture of Blue Black, Naples Yellow and Bright Violet. So far, so good.

2 BEGIN ROUNDING THE OBJECTS

In this step, really concentrate on rounding the vase and giving depth to the tabletop. Using a no. 1 filbert, place the vase's warmest tone, a mixture of Purple Madder, Cadmium Yellow Deep and Raw Umber, down the center to help round it. Add a light highlight of Magenta, White and Raw Umber on top of it, then light touches of Ultramarine Violet and Chrome Yellow down the sides and across the bottom.

Make the back of the tabletop recede with a cool mixture of Ultramarine Violet and Raw Umber, apply it with a no. 1 filbert. Use the same brush to apply a warm mixture of Magenta and Raw Umber to the front of the table to advance it.

3 SEE THE GEOMETRIC SHAPE

Here's where my mistake began: I needed to use warm and cool tones to round the flowers, warmer colors in the front, cooler in the back. Also, using brushstrokes that went against the direction of the petals—instead of with them—would have emphasized the fact that I needed to think of them as a mass instead of as individual petals. As a result, I got caught into thinking that I could fix the painting by adding more petals.

No amount of petals was going to fix this painting. I used more intense colors, which I usually do at this stage, but it just added to the confusion instead of adding a spark. I hadn't done flowers in a while and had forgotten my own advice: find the geometric shape of the flower, in this case, a cone. I've heard it said that for every month you stay away from painting, you need to expect to spend a day in the studio getting back to yourself.

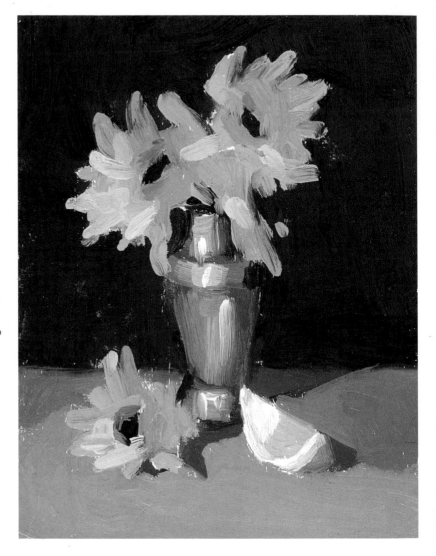

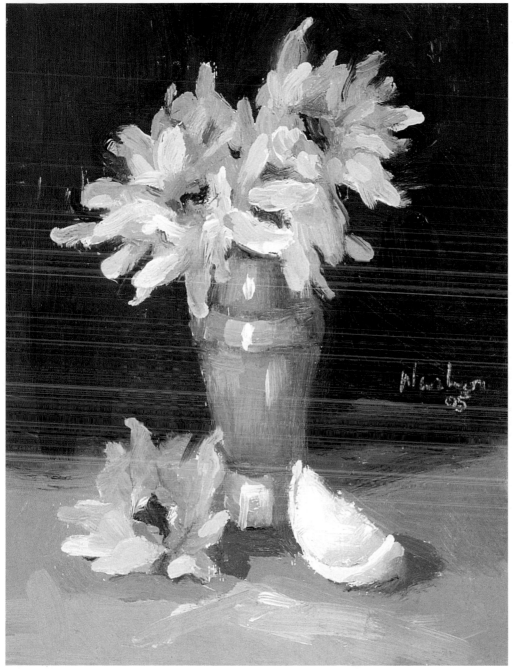

4 BACK TO THE DRAWING BOARD

There are way too many petals in these sunflowers. The petals on the flower on the tabletop are painted in a much looser fashion, and I like that so much better. It's back to the drawing board, this time to model all the flowers like the one on the tabletop: starting with a cone.

SUNFLOWERS AND LEMON ~ Oil on board, 3¾" × 3" (10cm × 8cm)

The Self Critique, Part II

For my next attempt at this painting, I changed the background fabric from the previous setup. I told myself I did it so I wouldn't be worrying about dragging the dark color into the sunflower color, but in retrospect, I think it had more to do with getting back to my comfort zone. Maybe I was relying on this too much: I ran into the same problem in this painting as in the previous one.

I did not use changes in color temperature to round all the forms; in fact, I used the same colors I had for the first flowers, with the exception of a brighter color used in the front. More variation is needed. (What was I thinking?! Of course, hindsight is 20/20.)

The flower on the left has many more tone differences but is confusing, because I strayed from the foundation laid down in the block-in of the first step. The flower on the tabletop is the only flower that was done correctly—again! The brushstrokes don't follow the direction of the petals: They go across instead of up and down (right angles). There is variation in color temperature and the brushstrokes are loose and confident.

The vase works. It's simple and the color choices are right on. The lemon is basically painted the way I like it, except for the lack of color variation in the pinks—the pink at the back of the lemon could have been cooler, or the pink in the front warmer. If I did this painting again I would adjust the background color and round the sunflowers with more changes in color temperature and color intensity. I would also think of the flower as a geometric shape (cone) and paint its planes.

There are definitely good things about momentarily forgetting how you usually paint—for one thing, it gives you fresh ground to invent something new. It's a way of seeing things from a fresh and new vantage point, and the chances of making an artistic discovery are greater since you're not encumbered by old routines.

We can get into a rut and start repeating ourselves. The trick is to develop your own style, but not to overuse the same colors and compositions. However, whether you're forgetting your tried and true means of painting or covering well-worn territory, for your work to look its best you should always stick to the basic rules of painting.

FIXING A PAINTING FROM THE ❧GROUND UP❧

If I were going to do another version of this painting, I would change my drawing from this first one, which I used for both of these paintings, to a more geometric, simple sketch that would keep me from adding too many petals and show the plane changes more clearly.

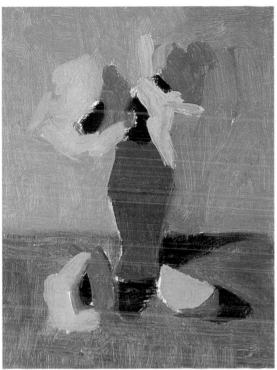

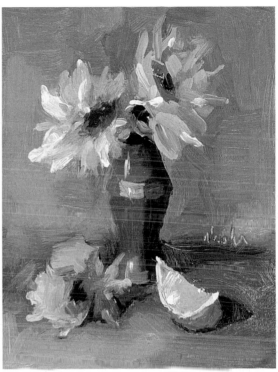

1 BLOCK IN THE BASIC SHAPES

This time, I thought I'd try a return to my comfort zone and painted the background a much lighter mixture of Violet Grey, Magenta and Raw Umber using a no. 2 filbert. The cast shadow in the background was done with the same brush using Violet Grey and Raw Umber. I tried to concentrate more on the geometric shape and warm and cool tones of the flowers, but the colors used are basically the same as those in the first painting.

2 FINISH THE SECOND ATTEMPT

This second version is still not a complete success. If the dark background had been kept, there would have been more room to experiment with the values. With the lighter background, the flowers need White to add variety and make them stand out, and this makes them appear a little pasty.

Also, the shadow color in the background is too interspersed throughout—it would be more interesting if different colors had been used. The brushstrokes could also use more variation. However, the trial and error process of painting, particularly on small canvases using little paint and supplies and moving quickly, is half the fun! Experiment until you find something you like.

❋ SUNFLOWERS AND LEMON #2 ～ Oil on board,
 3¾" × 3" (10cm × 8cm)

Gallery

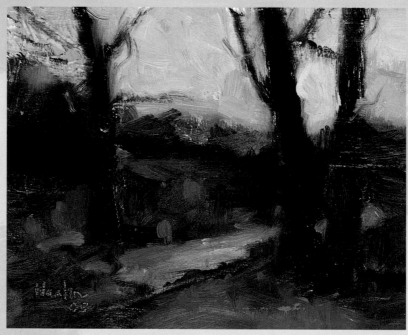

❧ IRON TREES ~ Oil on board, 3" × 3¾" (7cm × 10cm)

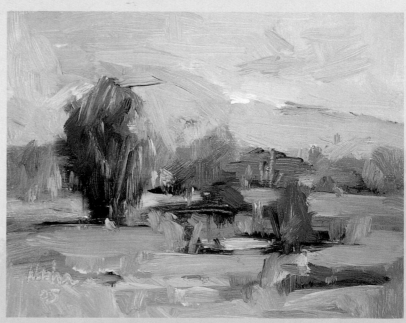

❧ LANDSCAPE #0539 ~ Oil on board, 2⅞" × 3¾" (7cm × 10cm)
~ Collection of Karen Shannon

ROSE RED ~ Oil on board, 3⅜" × 2½" (9cm × 6cm)

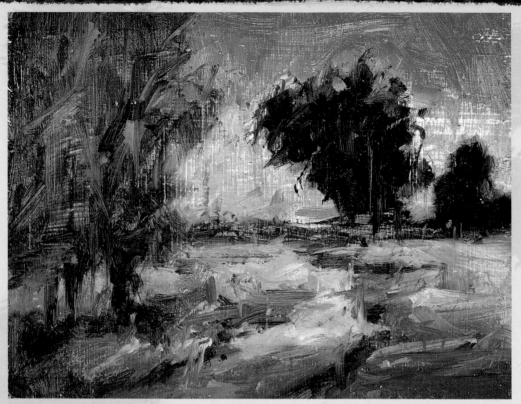

✦ LANDSCAPE #0317 ~ Oil on board, 2⅞" × 3¾" (7cm × 10cm)

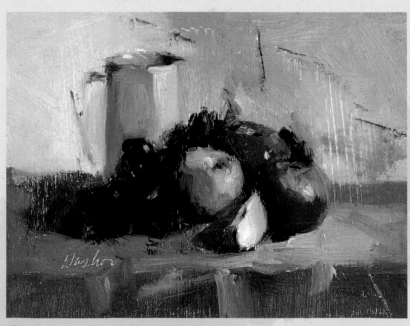

✦ THREE APPLES ~ Oil on board, 2⅞" × 3¾" (7cm × 10cm)

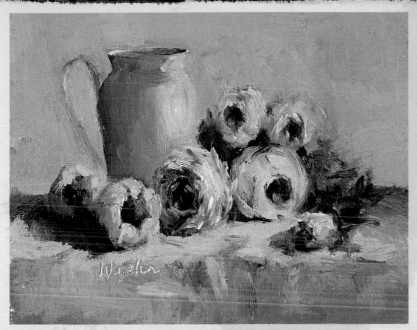

WHITE ARRANGEMENT ON PURPLE GROUND ~ Oil on board, 2⅞" × 3¾" (7cm × 10cm)

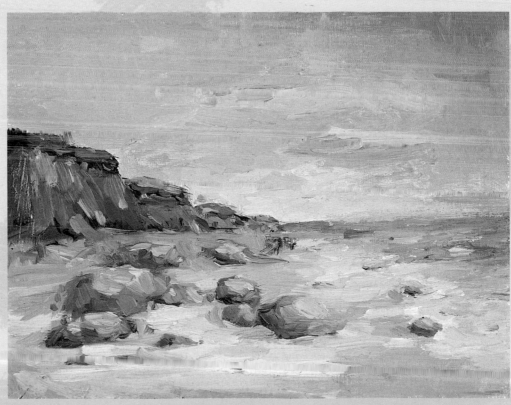

BEACHSCAPE ~ Oil on board, 2⅞" × 3¾" (7cm × 10cm)

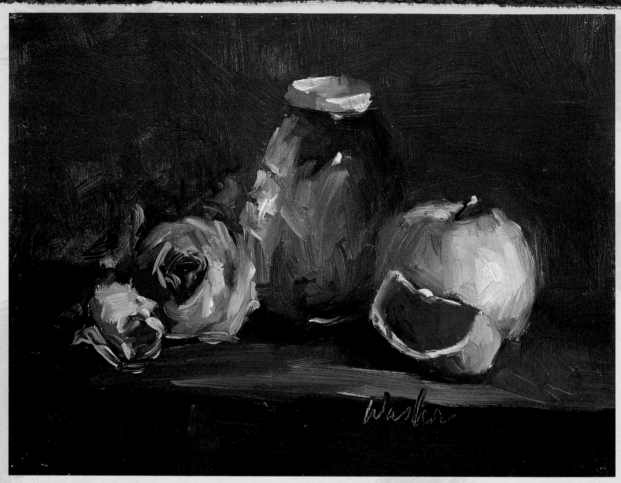

✿ RED/GREEN COMPOSITION ~ Oil on board, 2⅞" × 3¾" (7cm × 10cm)

✿ WINTER SNOW ~ Oil on board, 2⅞" × 3¾" (7cm × 10cm)

SUNFLOWERS AND GRAPES ~ Oil on board, 3⅝" × 2⅜" (9cm × 6cm)

Index

LEARN TO PAINT LIKE THE PROS WITH THESE OTHER FINE NORTH LIGHT BOOKS!

Light appears as reflection, glow and atmosphere. In painting, success hinges on your ability to capture light's subtleties, whether bright and bold or soft and shadowed. *Dramatic Light* demystifies this difficult aspect of painting with 25 step-by-step demonstrations in both watercolor and oil that show you how to see and paint light in its many forms.

ISBN-13: 978-1-58180-658-8, ISBN-10: 1-58180-658-2, HARDCOVER, 128 PAGES, #33253

Capturing the weather realistically can make the difference between a lifeless landscape and one that leaps off the page. Follow some of North Light Books' best-selling authors through 25 projects designed to teach you the secrets to capturing the light at different times of the day, creating various climates and conditions and rendering many different subjects.

ISBN-13: 978-1-58180-887-2, ISBN-10: 1-58180-887-9, PAPERBACK, 192 PAGES, #Z0275

If you have ever struggled with a creative block or found that the muse just won't materialize and inspire you, this kit is for you! This unique book and card game is packed with creative prompts and idea sparkers that will open a realm of creative possibilities that will lead you to a more personal and confident artistic style.

ISBN-13: 978-1-58180-875-9, ISBN-10: 1-58180-875-5, KIT: 96-PAGE BOOK, 3 CARD DECKS, #Z0345